IMAGES
of America

SHAKER HEIGHTS

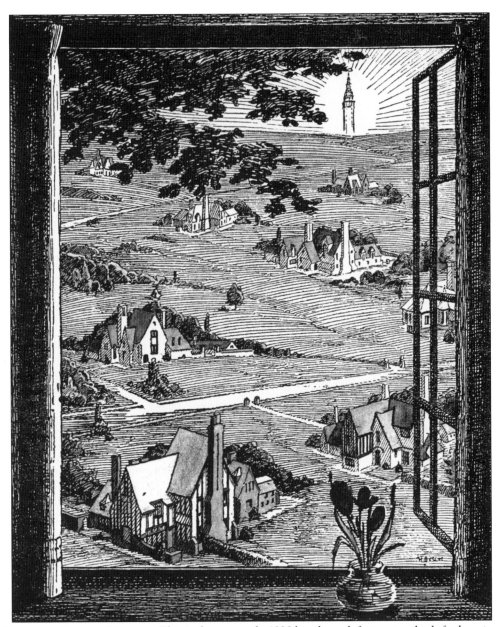

PEACEFUL SHAKER VILLAGE. This is the cover of a 1928 brochure defining standards for housing in Shaker Heights. "The most pleasing is never conspicuous—never flashy," it states. Apparently, these substantial homes were not considered flashy but a natural expression of life in the pastoral setting that was Shaker Heights. Shining as a beacon on the horizon is Terminal Tower, the Van Sweringen brothers' downtown Cleveland landmark. (Shaker Historical Society.)

On the cover: The Shaker Heights Community Rose Garden was established in 1925 with funds donated by residents. Almost 2,000 bushes were purchased and planted on land along Woodbury Road between Onaway School and Shaker Heights High School (now Woodbury Elementary School). This photograph was taken in 1931. Today the garden is maintained by community volunteers. (Cleveland State University.)

IMAGES
of America

SHAKER HEIGHTS

Bruce T. Marshall

ARCADIA
PUBLISHING

Published by Arcadia Publishing
Charleston SC, Chicago IL, Portsmouth NH, San Francisco CA

Printed in the United States of America

Library of Congress Catalog Card Number: 2006924296

For all general information contact Arcadia Publishing at:
Telephone 843-853-2070
Fax 843-853-0044
E-mail sales@arcadiapublishing.com
For customer service and orders:
Toll-Free 1-888-313-2665

Visit us on the Internet at http://www.arcadiapublishing.com

For Amy

CONTENTS

ACKNOWLEDGMENTS

Many people in Shaker Heights and beyond have generously shared their time, resources, and expertise in support of this book.

I would like to express my thanks to Cathie Winans and the staff of the Shaker Historical Society; Meghan Hays, local history librarian of the Shaker Heights Public Library; Lynn M. Duchez Bycko, who helped me negotiate the Cleveland Press Collection at Cleveland State University; Sue Starrett of the Shaker Schools Foundation; and Steve Cadwell of the Nature Center at Shaker Lakes. Thank you also to Sue Starrett, Mary Jo Groppe, Cathie Winans, and Maxine Jacqmin for their perceptive reading of the draft manuscript and their many helpful suggestions. Thank you also to my editors at Arcadia Publishing, Melissa Basilone and John Pearson, for their attentive care given to this project.

The photographs in this book come from several sources. Each is identified individually in the photograph caption: from the collection of the Shaker Historical Society, Nord Library, Shaker Heights (SHS); Local History Collection of the Shaker Heights Public Library (SHPL); Cleveland Press Collection at Cleveland State University Library (CSU); the Shaker Heights City Schools (SHCS); and the Nature Center at Shaker Lakes (NCSL). Those photographs whose source is not identified are from my personal collection. I appreciate the willingness of these institutions to make their photographs available.

Thank you to my wife, Amy Dibner, for her love and support. Amy, it would not have happened without you. And to our children and stepchildren—Aaron, Megan, Eli, and Katie. It is a joy to see you grow up and take your own places in the world.

INTRODUCTION

For almost 200 years, the site of today's Shaker Heights has hosted a series of planned communities. Residents have sought to create an ideal society guided by values that set it apart. The specific visions might seem quite different, from the communal religious colony of the North Union Shakers to the wealthy enclave of Shaker Heights to today's diverse inner-ring suburb. But there are themes that connect these communities.

From 1822 until 1889, the United Society of Believers in Christ's Second Appearing—more commonly known as the Shakers—created a separatist community to the east of Cleveland. Ralph Russell, a landowner in the area, converted to the Shakers. He then convinced his family and many neighbors to join with him and create the North Union Shaker settlement.

The Shakers originated in England during the mid-1700s when a small group broke away from a Quaker meeting. A devout young woman named Ann Lee soon joined this congregation and became its most important figure, helping formulate its beliefs and practices. Because of continued persecution, "Mother Ann" led the group out of England to the United States, where they settled in Watervliet, New York. Over the next century, 19 Shaker communities were established in the United States, including Union Village at Lebanon, Ohio, which sponsored North Union.

Shakers lived in celibate communities with men, women, and children in separate quarters, and their buildings featured separate entrances for the sexes. Shaker worship involved music and dance and often brought participants into states of ecstasy in which they claimed to receive communications from the spirit world. All work in a Shaker community was done for the glory of God, an approach that encouraged innovation in doing the tasks of everyday living. Shakers are credited with many inventions to make that work more efficient. Shaker furniture was known for its utility and durability, and customers outside the Shaker community regarded products sold by them as superior in quality. The North Union village peaked during the mid-1800s and then declined until 1889 when it disbanded, the remaining members moving to other Shaker settlements.

At the time, nearby Cleveland had developed into an industrial powerhouse—a center of the nation's oil refineries and steel production. Incredible wealth resulted as well as serious industrial pollution and social problems. This combination of elements created an opportunity recognized by two brothers, Oris Paxton (O. P.) and Mantis James (M. J.) Van Sweringen. They conceived a community where prosperous people would be protected from the unpleasantness of big-city life. The Van Sweringen brothers purchased property including most of the former Shaker village where they built their garden city suburb, Shaker Heights.

Shaker Heights billed itself as a paradise, and in a sense it was: luxurious homes, ample green space, and a public life that supported the values of its residents. The architecture of public and private buildings, the city services, libraries, and schools set high standards. A source of particular pride in Shaker Heights was the school system, seen as among the best in the nation. The good life in Shaker Heights was also supported by its social activities, its country clubs, and shopping aimed at the wealthy consumer. Shaker Square was developed to serve this clientele; it was one of the first shopping centers in the nation.

Similar to the earlier Shaker colony, Shaker Heights was set apart from the rest of society. The Van Sweringen Company wrote restrictions into housing contracts to maintain the nature of the city forever. Nevertheless, change came to Shaker Heights. The housing stock aged, apartment buildings added a new population, white flight loomed as African Americans moved into Shaker Heights, and two freeways were proposed that would have sliced through the center of the city.

In response, citizens of Shaker Heights rallied and sought to protect their community by reinventing it. Residents embraced the change in population with planning that promotes diversity. Citizen action defeated the highways and established a nature center where concrete would have been. And strict guidelines encouraged (or forced) homeowners to maintain their property. As a result, Shaker Heights has become a stable integrated community, the schools have built on their tradition of excellence, and the city retains its grace with classic housing and green space throughout.

"Most communities just happen; the best are planned." This early advertisement from the Van Sweringen Company states a belief that continues to guide Shaker Heights. Unlike most towns and cities that "just happen," life in today's Shaker community is intentionally shaped by a set of values and standards. But instead of supporting a separatist religious colony or an enclave of wealthy residents, Shaker Heights now offers what few communities have achieved: a stable integrated city that embraces the diversity of its people and draws upon that diversity to enrich the common life of its residents.

One

THE VALLEY OF GOD'S PLEASURE

Jacob Russell was 67 years old in 1812—a veteran of the American Revolution—when he and 19 other members of his family journeyed from Connecticut to northeast Ohio to start a new life. Jacob sold the gristmill he had operated to buy land in Warrensville Township where the Russell family built cabins and cleared the land for farming.

Jacob's son Ralph was a warmhearted man with contagious enthusiasm who attracted people to him. He was also a spiritual seeker intrigued by his introduction to the Shakers while spending the night in the home of a new convert. After his father's death in 1821, Ralph walked 260 miles to the Union Village Shaker settlement near Lebanon, Ohio, to experience the community for himself. His stay extended for months, and he became convinced that Shakerism offered a life filled with spirit. He returned home to persuade his family to join with him in creating a Shaker community. Ralph Russell reported that as he returned to Warrensville, he was accompanied by "a clear ray of light" that ended at a spot near his cabin where it became a beautiful tree.

From 1822 until 1889, Shakers of the North Union settlement lived on property east of Cleveland that grew to almost 1,400 acres. At its peak in the mid-1800s, about 300 people resided there, divided into three "families," each with its own structures: the Center Family, the East Family, and the Mill Family. Shaker communities sought to create the kingdom of heaven on earth by leading pure lives in which they would be open to the call of the spirit. This involved communal living, confession of sin, celibacy, and ecstatic worship in which music and dance were key elements. The products Shakers sold to support themselves became known for their quality and utility.

During the 1840s, a wave of spiritual enthusiasm swept the North Union Village in which participants heard communications they believed were sent from God directly to them. One such message gave the community a new name, the Valley of God's Pleasure.

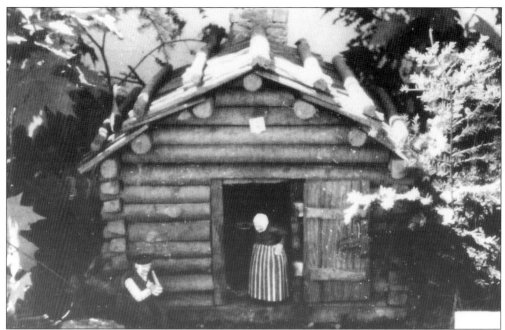

MODEL OF FIRST WARRENSVILLE CABIN. In 1808, Daniel and Margaret Warren moved from New Hampshire to northeast Ohio and built a cabin near the intersection of Lee and Kinsman (now Chagrin Boulevard) Roads. After a day of sleighing, friends from Newburgh, Ohio, crowded into their cabin for a housewarming, and Margaret was asked to suggest a name for their location, then known only as Township 7. She chose Warrensville. (SHS.)

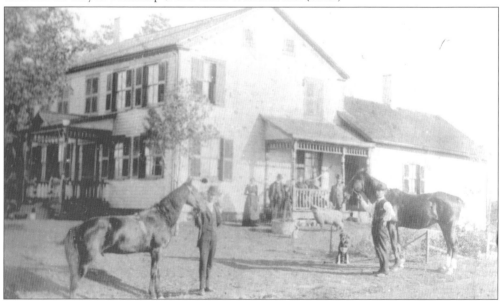

MOSES WARREN HOUSE. Daniel Warren's father, Moses, followed his son and daughter-in-law to Ohio and in 1817 built a home on a ridge south of Kinsman Road. He chose a location near a creek, which he channeled through the cellar to provide refrigeration. Warren family descendents lived here until 1865. Today it is the oldest house in Shaker Heights and the oldest frame house in Cuyahoga County. (SHS.)

RALPH RUSSELL. Ralph and Elijah Russell came to Warrensville Township before their family to clear land on property their father, Jacob, had purchased. The brothers then returned to Connecticut and led a group of 20 family members back to Ohio. They settled along Lee Road near Doan Brook. After his father's death in 1821, Ralph converted to Shakerism and convinced members of his family to join also. (SHS.)

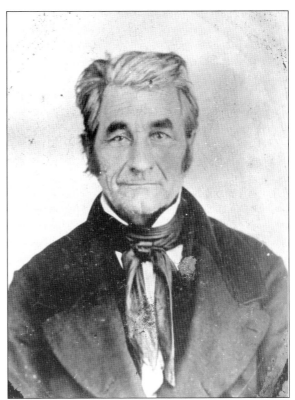

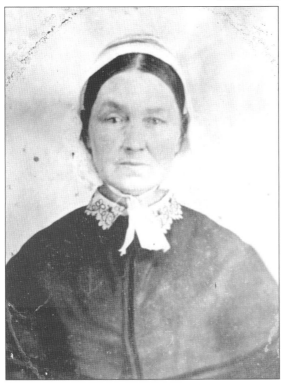

LAURA RUSSELL. After helping his family establish its homestead, Ralph Russell went back east to marry. He and Laura Ellsworth had met as children. He now proposed that she join him in Ohio, and she agreed. The couple had three children before they joined the Shakers and four more children after they left North Union in 1828. (SHS.)

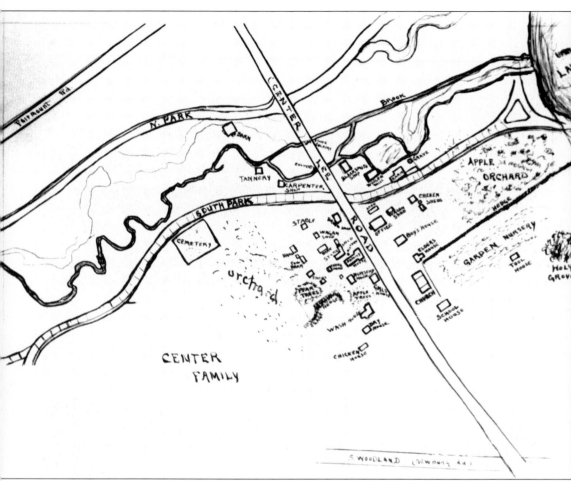

CENTER FAMILY MAP. When Ralph Russell walked the 260-mile journey home from Union Shaker Village in Lebanon, Ohio, he reported that he was accompanied by a "clear ray of light" that ended at a spot near his cabin. There the new Shaker community built its first structure, the Center Family Dwelling House. When completed, North Union adopted the Shaker practice of breaking up nuclear families with separate quarters for men, women, boys, and girls. Later other structures were added, including a meetinghouse, an administration building that also served as the guesthouse, a boys' house, a girls' house, a blacksmith's shop, a woolen mill, a carpenter shop, a barn, and several buildings for the community's farming. This map shows Fairmount and Lee Roads, which predate the Shaker settlement. North Park and South Park Boulevards, also shown on this map, were created by developers after the Shakers had abandoned the property. (SHS.)

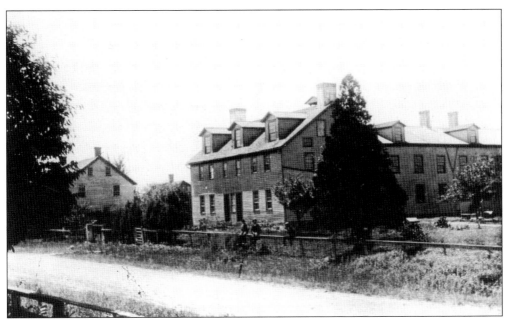

CENTER FAMILY DWELLING HOUSE. The completion of the first structure marked a change in the new North Union settlement. Shaker rules regarding separation of the sexes were instituted, and Ashbel Kitchell, an elder from Union Village, arrived to assume leadership, thus displacing the founder, Ralph Russell. Soon thereafter, he and his family left North Union and settled on a farm near Solon. He did not return to the Shakers. (SHS.)

CENTER FAMILY HOUSE FROM SOUTH. This photograph was taken at about where Shaker Boulevard today crosses Lee Road and shows the Center Family House from the opposite direction than the above picture. The tall tree in the distance is where Lee intersects with Fairmount Boulevard (then Fairmount Road). Lee Road was named for Elias Lee, an early settler who donated land for this road. (SHS.)

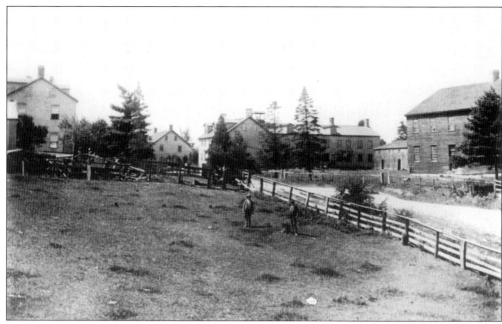

CENTER FAMILY BUILDINGS. The Center Family Dwelling House is at the center. To its left is the girls' house; to the right is the woodshed and the Red Shop, which received its name from the color it was painted. A red building was unusual because Shakers were advised not to paint their structures red, black, or brown but instead to use a "lightish hue." (SHS.)

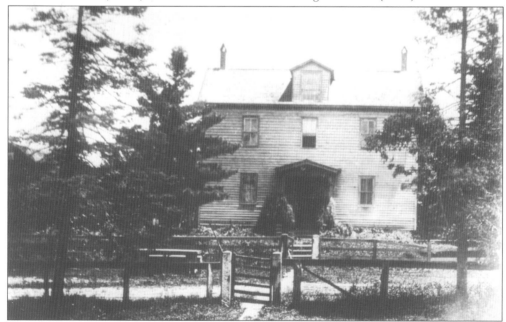

OFFICE AND GUESTHOUSE. This building served as administrative headquarters and also hosted visitors. Shakers often traveled to other Shaker settlements and enjoyed extended visits of weeks or months. An ethic of hospitality governed the communities with hosts offering full access to their facilities and presenting the travelers gifts of food and cash to ease their journeys when they moved on. (SHS.)

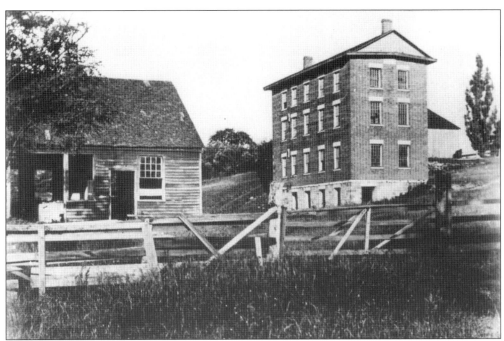

WOOLEN MILL. The upper story contained a spinning jack of 150 spindles, two power looms for weaving cloth, and a twister. The next floor down had carding machines, and the floor below that contained a lathe for turning broom handles. In the basement were a large grindstone and a buzz saw for sawing wood for lumber. All the machinery was run by waterpower. (SHS.)

SHAKERS BLEACHING WOOL, 1876. North Union produced woolen stockings, mittens, and gloves for their own use and for sale. These goods were of high quality, so they could compete successfully with woolens made more cheaply in Cleveland mills. Specialty mittens woven from wool and raccoon fur were said to be especially soft. (SHS.)

15

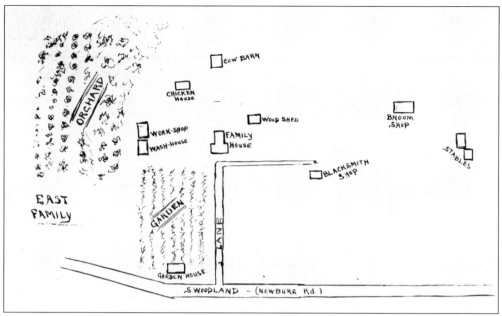

EAST FAMILY MAP. Shaker communities were organized into "families," each containing up to 100 people. The East Family focused on rearing orphans, children of parents in the colony, and other dependent children. The family also tended a large orchard and garden whose surplus was sold to residents of surrounding villages. As with their other products, Shaker fruits and vegetables had a reputation of high quality. (SHS.)

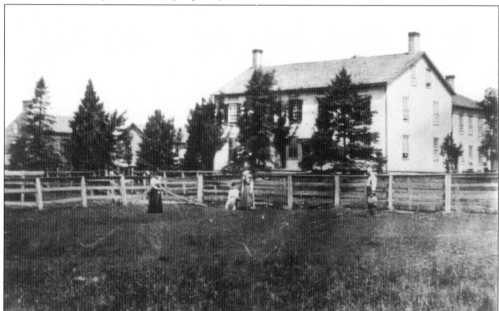

EAST FAMILY DWELLING HOUSE, 1869. Upon entering a dwelling house, Shakers removed coats, hats, or bonnets and hung them on pegs mounted along the wall. Nothing was carelessly strewn about, and everything had its proper place. Mother Ann Lee had taught that order was one of heaven's laws. A visitor to North Union observed, "There was a neatness like a halo to the place." (SHS.)

16

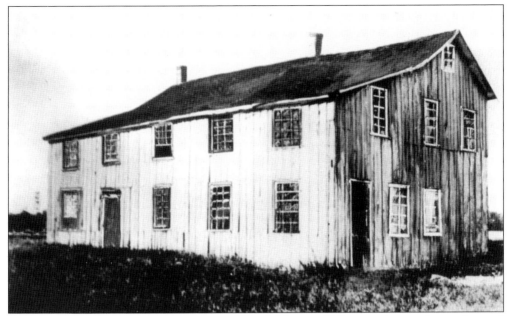

EAST FAMILY BROOM SHOP. The Shakers of North Union sold farm produce and manufactured items to the surrounding community. Among their products were copper pails, churns, maple syrup, medicinal herbs, shoes, leather harnesses and saddles, and garden seed packets. Flat brooms were big sellers—an appropriate product since Shaker facilities were kept so clean, reflecting Mother Ann's teaching: "In Heaven there is no dirt." (SHS.)

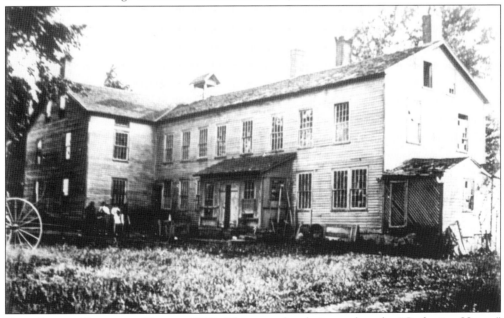

EAST FAMILY DWELLING HOUSE, 1898. This was also designated as the "Gathering House," where those new to the community lived. Some people joined the Shakers in the fall, before cold weather hit, and then went elsewhere when spring arrived. They were called "Winter Shakers." Often these were Great Lakes sailors with no place to go during the cold weather months who worked in exchange for food and lodging. (SHS.)

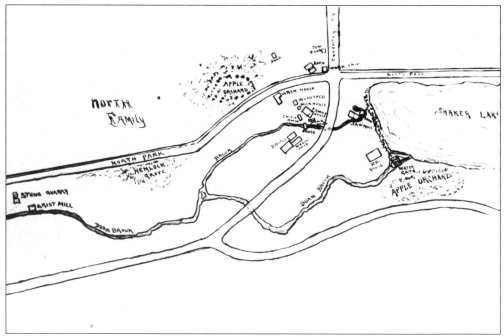

MILL FAMILY MAP. The Mill Family was in charge of the gristmill and the sawmill. The gristmill ground grain for both the Shaker settlement and for farmers in the region. The sawmill cut logs into boards used in constructing the buildings at North Union. Mill Family members also worked the stone quarry, which was located near the gristmill. (SHS.)

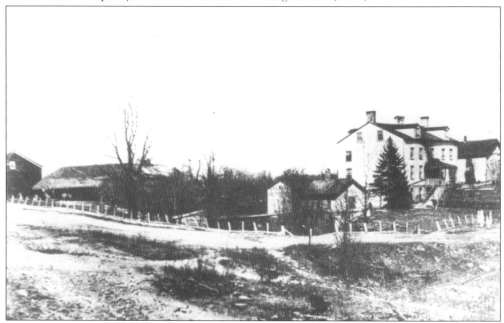

MILL FAMILY BUILDINGS. The Mill Family buildings shown here are, from left to right, the horse barn and shed, the cheese house, and the dwelling house, built in 1838. Doan Brook ran between the shed and the family house. These structures were located just west of the present Coventry Road near the end of Lower Shaker Lake. (SHS.)

DOAN BROOK. This nine-mile stream runs northeast from its start near Green Road, emptying into Lake Erie. In 1826, the Shakers dammed Doan Brook for waterpower, which ran the gristmill and sawmill. This created Lower Shaker Lake. In 1854, the Shakers built a second dam that created Upper Shaker Lake, known today as Horseshoe Lake. In this 1876 photograph, a man pauses to drink from Doan Brook. (SHS.)

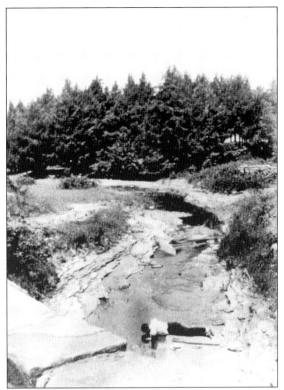

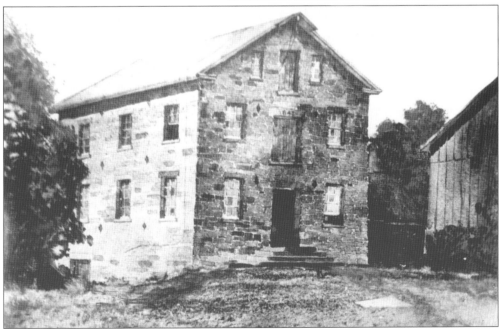

NORTHEAST VIEW OF GRISTMILL. Built in 1843, this gristmill was constructed of stone from the quarry operated by the Mill Family. Facing north, it stood two stories high; to the south, it rose four stories, creating a 40- to 50-foot fall for the water that ran the mill. It was solidly constructed with four-foot-thick walls. Many considered it the finest gristmill in Ohio. (SHS.)

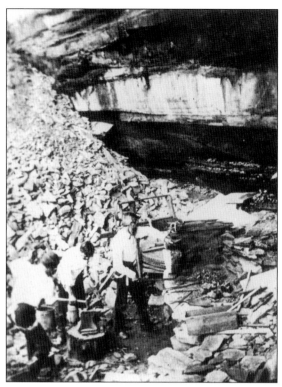

SHAKERS WORKING STONE QUARRY, 1876. The quarry supplied stone for building the gristmill as well as for foundations of structures in the colony, posts, sidewalks, dams, and tombstones. It was filled in with construction material when the Baldwin Reservoir of the Cleveland Waterworks was built in 1919. (SHS.)

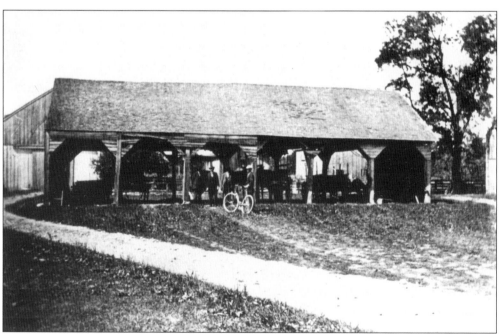

WAGON SHED OF MILL FAMILY, 1880. This wagon shed was built in 1837 and located next to the barn. Most buildings of the Mill Family were destroyed in a fire in 1890. One Shaker remained at the time. He was reported to have watched the dwelling house burn with a smile on his face. "It is well enough," he said, "The building had served its purpose." (SHS.)

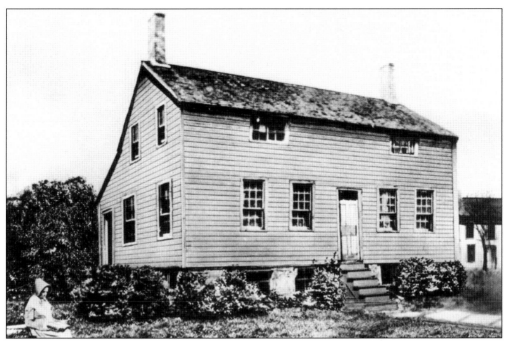

SHAKER HOSPITAL. The North Union settlement built a hospital, but it was rarely used because the Shakers were not often sick. The hospital building included a nursery; the Shakers took in orphans, and new members often arrived with small children. This shot was taken in 1898 after the Shakers had left. The woman in the foreground was added to the picture by the photographer. (SHS.)

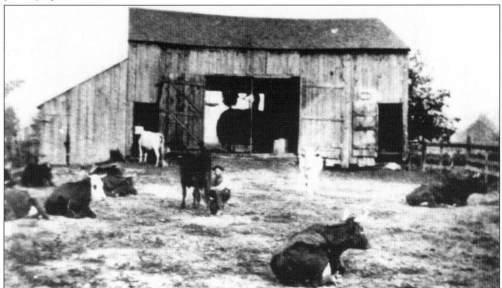

DAIRY HERD. North Union dairy cattle supplied the colony with milk and cheese. The Shakers also sold dairy products, offering home delivery in surrounding villages and into Cleveland. The land was not suited for many crops because of a hard layer of clay beneath the surface, so they specialized in crops such as corn that did well in poor soil. They used other fields for grazing livestock. (SHS.)

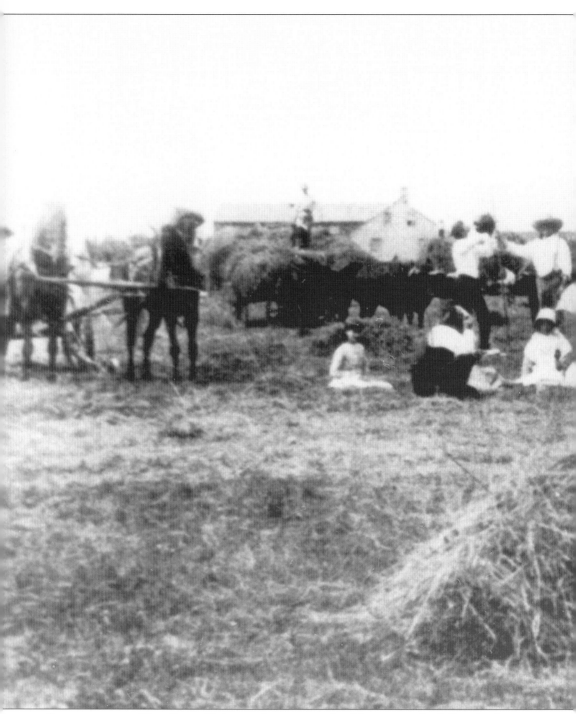

SHAKERS IN THE HAY FIELD. "It is a perfect summer day. Not even a cloud disturbs the peace of the scene where out in the meadows the scythes of the brethren move in complete rhythm, while the sisters move quietly along the even rows gathering berries and sweet smelling herbs in their well-kept gardens. Off in the distance a group of small children are winding their way along the bank of the brook for a day's outing. The whole village seems to be moving in unison—there

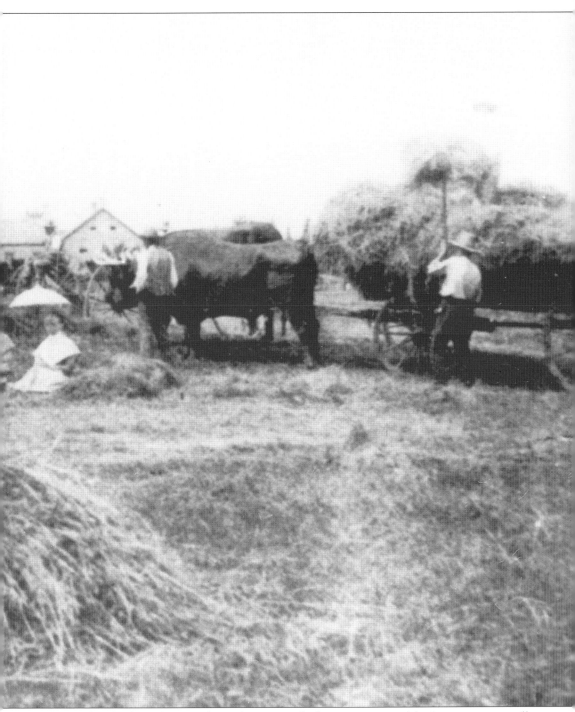

is almost the rhythm of music about the scene which impresses one like listening to a well conducted concert." The quotation is from Elder Hiram Rule's journal dated 1844. This 1876 photograph shows Shaker sisters seated with umbrellas while a Shaker brother loads hay onto a cart pulled by oxen. (SHS.)

CLYMENA MINER. As a six year old in 1838, Clymena Miner joined the Shakers at North Union. She had a beautiful voice and was said to "sing with spirit and understanding." A contemporary described her as an unusually pleasant person, "well informed and an excellent conversationalist." She held the position of eldress during the difficult last years of the society. (SHS.)

JAMES PRESCOTT. James Prescott initially came to North Union as a stonemason to help build the Center Family Dwelling House. He stayed, became a member, and lived at North Union until his death in 1888. He left behind a diary, the most complete written account of life in this Shaker community. He also served as headmaster of the school for 40 years. (SHS.)

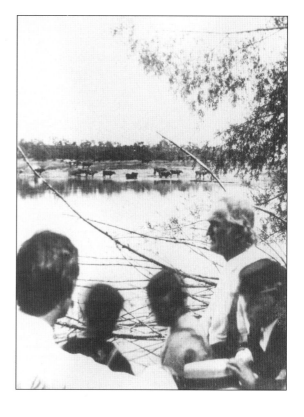

JOHN PILOT. John and Maria Pilot and their four children arrived at North Union from upstate New York in 1858. Upon joining the community, the family unit was split up: the father joined the brothers, the mother joined the sisters, and the children went to their separate quarters. From then on, children were to address their parents as Brother and Sister, not Father and Mother. (SHS.)

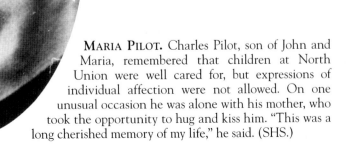

MARIA PILOT. Charles Pilot, son of John and Maria, remembered that children at North Union were well cared for, but expressions of individual affection were not allowed. On one unusual occasion he was alone with his mother, who took the opportunity to hug and kiss him. "This was a long cherished memory of my life," he said. (SHS.)

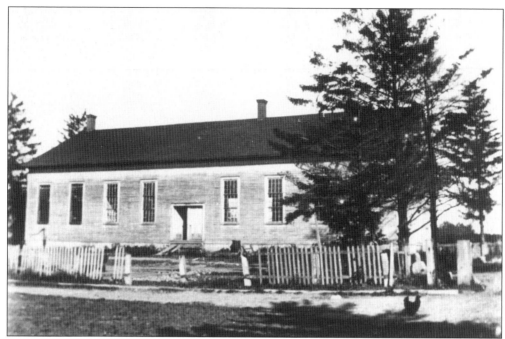

NORTH UNION SHAKER MEETINGHOUSE. The Shakers were founded in England in the mid-1700s as a breakaway sect of Quakers. Unlike the more sedate Quakers, Shaker worship included music, song, and dance, which often brought participants to shake in ecstasy. The group called itself the United Society of Believers in Christ's Second Appearing, but others referred to them, derisively, as "Shaking Quakers" or just "Shakers." The name stuck. (SHS.)

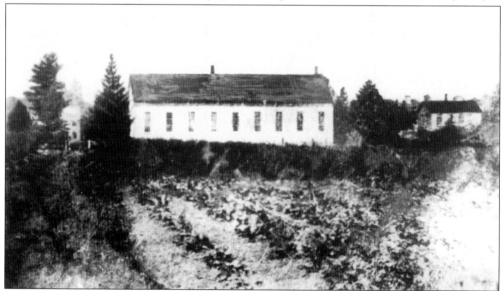

MEETINGHOUSE IN 1860. This view shows the rear of the meetinghouse with an extensive garden in the foreground. "Consecrated labor" was used to build this structure; that is, only members of the community worked on it. The exterior of the meetinghouse was white, the interior a deep "Shaker blue." It was dedicated on Thanksgiving Day, 1848: "A glorious occasion!" James Prescott wrote in his diary. (SHS.)

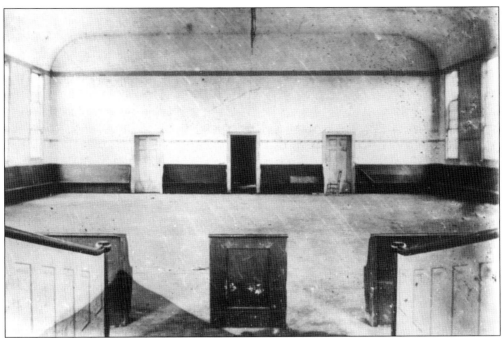

MEETINGHOUSE INTERIOR. The open area of the meetinghouse provided room for Shaker worship, which involved movement and song. According to one observer, "The words, the music, the gesturing, and the dancing all united to form a precision ensemble that would have done credit to a trained ballet corps." Separate entrances for brothers and sisters are visible here. (SHS.)

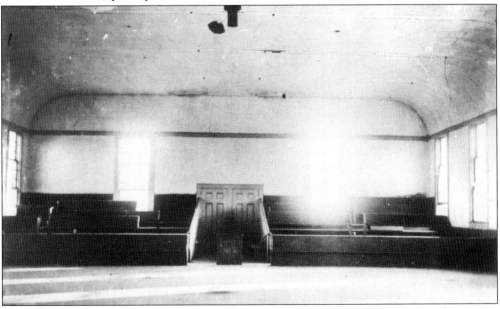

MEETINGHOUSE INTERIOR, OPPOSITE SIDE. The seating area shown in this view is for visitors. Shakers invited people from "the world" to observe their Sabbath worship services, and the galleries were often packed with the curious. Visitors reported that as many as 150 Shakers marched and sang and danced in this area, which was designed without interior supporting pillars that would restrict their movements. (SHS.)

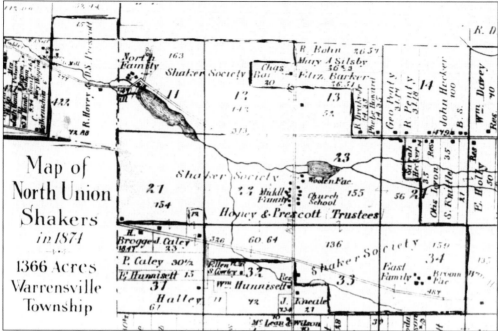

North Union Shaker Village, 1874. This map from an atlas shows the extent of Shaker property at its peak. Today the southern section is in Shaker Heights. The northern section is included in the boundaries of Cleveland Heights. Lee Road is marked with a double line running north and south. Fairmount Boulevard and South Woodland Road (then Newburgh Road) are shown with double lines running east and west. (SHS.)

Jehovah's Beautiful Square. This area, also known as the Holy Grove, was used for outdoor worship. Here North Union members gathered for singing and dance and praise. There was joyousness in Shaker life that might not be easily apparent, but perhaps it can be imagined in this clearing: "They danced until they trod the grass into the earth so that it was like an earthen threshing floor." (SHS.)

28

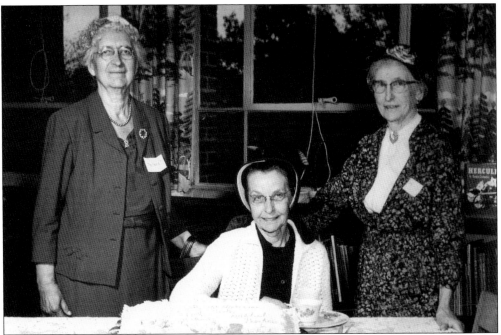

A SHAKER VISITS SHAKER HEIGHTS. In 1960, Sister Mildred Barker of the Shaker Society in Sabbathday Lake, Maine, visited Shaker Heights, where she met with children at Moreland School. Pictured here, from left to right, are Elizabeth Nord, a founding member and first curator of the Shaker Historical Society; Sister Mildred; and Frances Everhart, a teacher in the Shaker Heights schools. (SHS.)

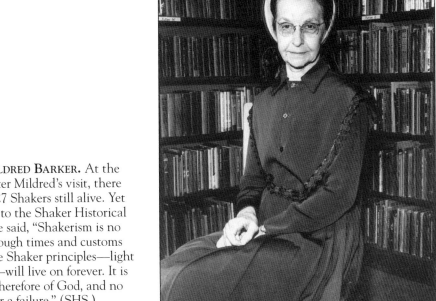

SISTER MILDRED BARKER. At the time of Sister Mildred's visit, there were only 27 Shakers still alive. Yet in remarks to the Shaker Historical Society, she said, "Shakerism is no failure. Though times and customs change, the Shaker principles—light and truth—will live on forever. It is good and therefore of God, and no good is ever a failure." (SHS.)

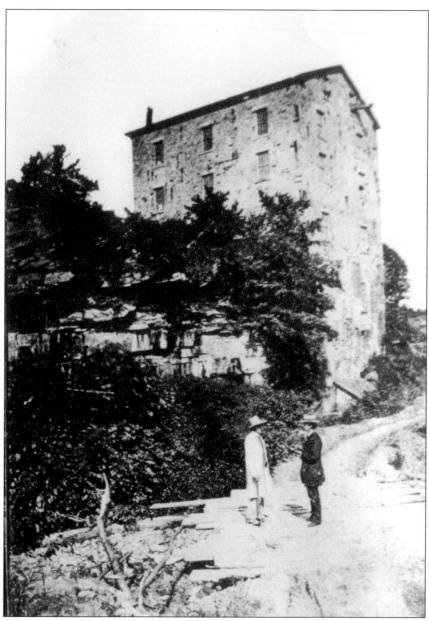

NORTH UNION GRISTMILL. The gristmill was the largest structure at North Union. It had been built both by Shakers and outside contractors hired by the community. The outside labor was needed because this building required more engineering expertise and heavy equipment than the Shakers had on their own. It was significant that North Union could afford this project—it cost them over $7,000 (almost $150,000 in today's dollars). The community was doing well, and their new gristmill was a visible sign of their prosperity. Forty years later, though, the fortunes of North Union had changed, and the mill was sold. James Prescott noted its passing in his diary: "This Shaker mill was built in 1843. Its walls were thick and solid. It had been one of Ohio's finest mills. It had fed countless hungry mouths. It had fulfilled its purpose; it had outlived its usefulness and had become a bill of expense. So farewell old mill! We Shakers will remember you for the good you have done." (SHS.)

Two

BLOWING UP
THE GRISTMILL

The afternoon's activities were orchestrated to thrill those gathered to celebrate July 4, 1886. First was a balloon launch that went awry when the balloon caught fire. Cannons blasted for over an hour, shaking everything in the area, and the Battle of Bull Run was reenacted. Finally the main event: Charles Reader, a Cleveland councilman, had purchased rights to stone in the Shaker gristmill, and he intended to reap full benefit from his investment. To close the celebration, he arranged to blow up the gristmill. The mill had been solidly constructed, and several blasts were required before it was turned to rubble for the pleasure of the crowd.

Among the spectators were a few remaining members of the Shaker community. Elder James Prescott wrote in his diary, "It took deep and heavy blasting from the inside with giant sticks of dynamite as if the mill did not wish to go. I feel, old mill, as if your going applies to me also."

The North Union Shaker settlement reached its peak in the 1850s but then began a slow decline. More people left the community than joined, and those who did remain were getting old. Part of their land was rented to farmers, the three families consolidated into one, and the gristmill became too expensive to operate. In 1889, Shaker elders closed North Union with the remaining 27 members moving to other Shaker communities.

A group of Cleveland investors purchased the land and began developing it. They then sold it to a company in Buffalo, New York, that marketed the property for housing lots, but there were few buyers. The location was too far from the Cleveland business district to make commuting practical. Meanwhile, the old Shaker buildings stood empty. Some were consumed by fire; others fell prey to neglect.

Yet a legacy remains from this interim period. At a gathering of the original investors, the question of a name for the development was raised. The wife of one investor noted that this property was in the hills above Cleveland and that Shakers had once lived there. Hence, Shaker Heights.

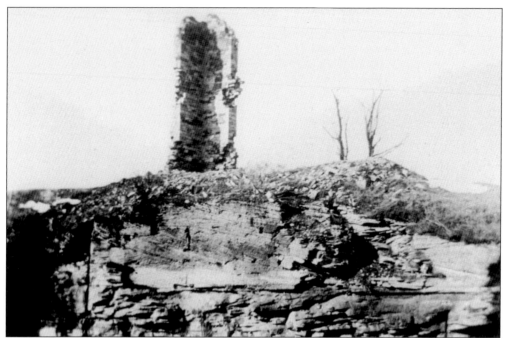

RUINS OF GRISTMILL. The gristmill was built during a time of prosperity for North Union, and it was a remarkable engineering achievement, rising 50 feet high above its base in a gorge. Visitors came from miles around to view the "famous Shaker gristmill." But as North Union declined, the community could no longer operate it. The stone used in its construction became more valuable than the mill itself. (SHS.)

ABANDONED MEETINGHOUSE. The North Union Shaker settlement declined for several reasons. One was its proximity to Cleveland and the lure of life in the city, particularly for young people. Another was the practice of celibacy; its appeal was limited and meant that new generations were not born to the Shakers. Furthermore, in post–Civil War America, separatist communities did not attract adherents as they once had. (SHS.)

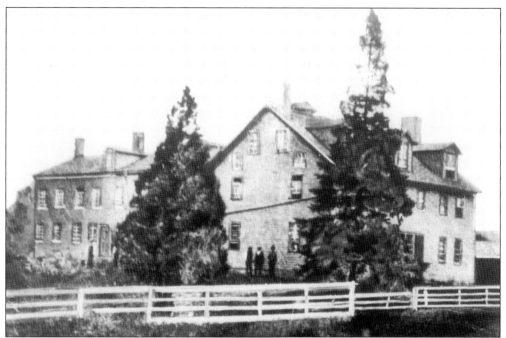

CENTER FAMILY DWELLING HOUSE, 1870. In May 1889, elders from Union Village visited North Union to consider its future. They reported that while the spirit was good among the remaining members, the building and grounds were not kept in good repair. Furthermore, Cleveland's growth east raised the prospect of property taxes far above what this community could afford. The decision was made to close North Union. (SHS.)

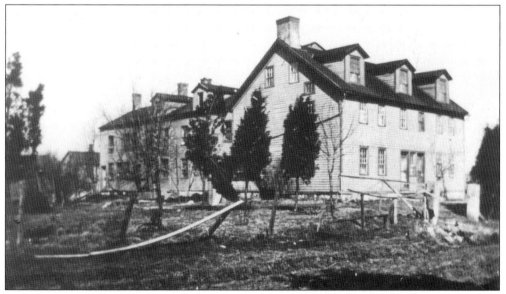

CENTER FAMILY HOUSE ABANDONED. This photograph was taken in 1898 about 10 years after the Shakers had left. The fence is now falling apart—a good indication that Shakers no longer lived here. They would not have let the fence deteriorate to that condition. The house was rented by several tenants before it was torn down by the Van Sweringen Company to make way for new housing. (SHS.)

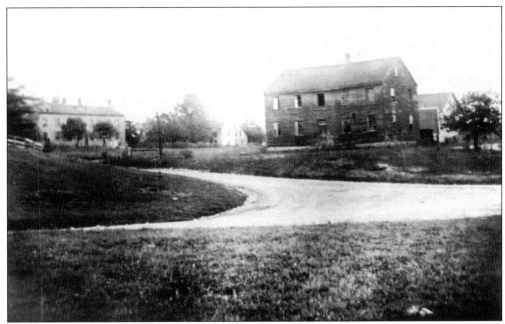

EMPTY CENTER FAMILY BUILDINGS. The small white building near the center is the facility where Shakers once made cheese. The large barn housed the dairy cattle. To the left is the Center Family Dwelling House. The Shaker buildings that were not consumed by fire stood vacant for years, while the Shaker fields and orchards were overrun with weeds and brush. (SHS.)

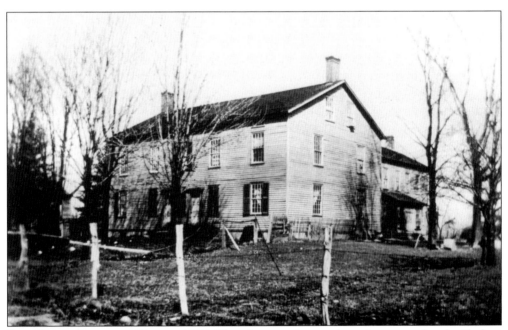

EAST FAMILY DWELLING HOUSE, 1898. This photograph was taken nine years after the Shakers closed North Union. Several years before that, remaining members of the East Family had joined with the Center Family, leaving this building vacant. Today's Fontenay Road runs through the site where the East Family Dwelling House had been located. (SHS.)

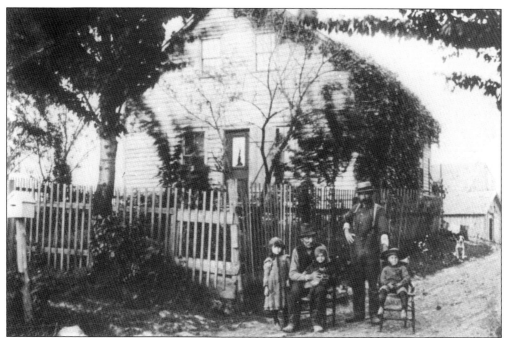

TANNERY CONVERTED INTO A HOME. The tannery had been built in 1829 and located by Doan Brook. After the colony was abandoned, this structure was sold and moved to a location near Lee and South Woodland Roads. At one time, the tannery had been the site of a thriving leather goods operation by the Shakers. In this photograph taken in 1900, the structure has been turned into housing. (SHS.)

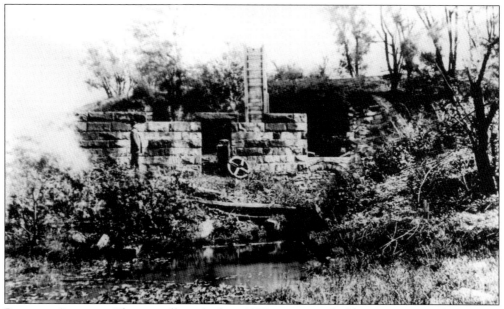

RUINS OF SAWMILL. The sawmill was built in 1837, constructed of frame on a stone foundation. An admiring visitor described the saw as "first rate" and exclaimed, "It thinks no more of sawing a four foot log than we would of slicing a piece of bread!" Today remnants of the foundation can be found near the southeast corner of North Park Boulevard and Coventry Road. (SHS.)

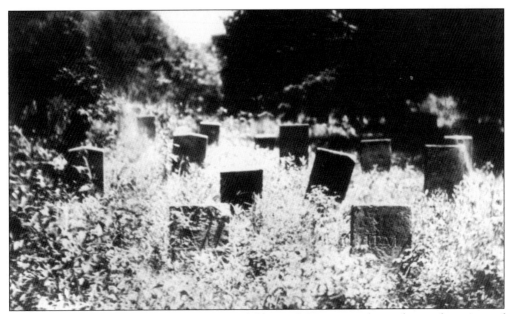

SHAKER CEMETERY, 1894. The burial ground for North Union was located near the corner of an orchard to the west of the Center Family Buildings. Today that location is west of Lee Road, near South Park Boulevard. Shakers separated the sexes even after death: females in one section, males in another. Headstones were usually of sandstone and featured only the initials of the deceased. (SHS.)

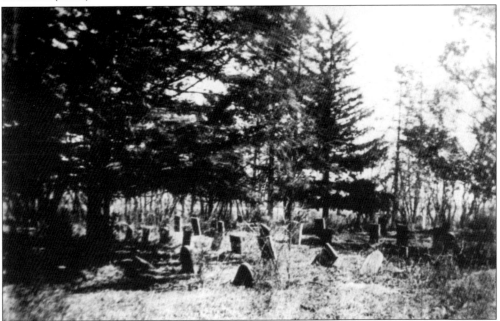

SHAKER CEMETERY, 1898. The cemetery was removed in 1909 as developers readied land for roads and housing plots. The remains were exhumed and interred in a mass grave at the Warrensville West Cemetery on Lee Road. Records kept by the Shakers indicate 137 burials at their cemetery, but the remains of only 89 people were identified for reburial. At the time, the new burial site was left unmarked. (SHS.)

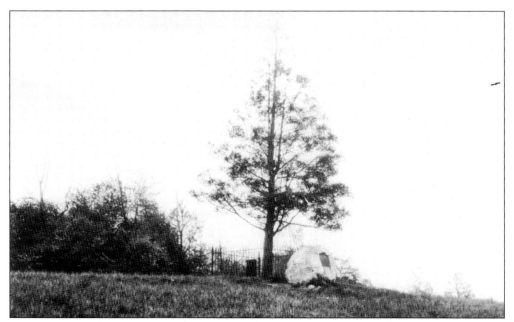

JACOB RUSSELL GRAVE. One grave remains at its original site, which was separate from the Shaker cemetery: Jacob Russell, father of Ralph Russell, who moved his family from Connecticut to Warrensville Township in 1812. The gravestone identifies him as having served in the Connecticut Continental Regiment during the American Revolution, born in 1746, died in 1821. Today the site is on South Park Boulevard, just east of Lee Road. (SHS.)

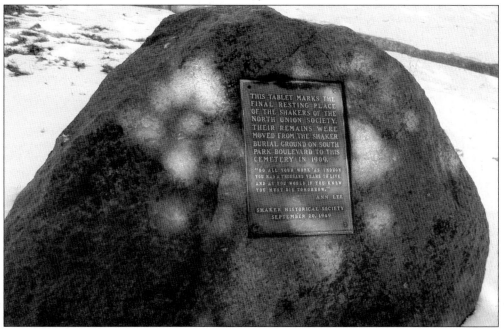

SHAKER GRAVE SITE. In 1949, the Shaker Historical Society placed a stone at the mass grave of the Shakers who had been moved to the Warrensville West Cemetery. On it are inscribed words of Shaker leader Mother Ann Lee: "Do all your work as though you had a thousand years to live. And as you would if you knew you must die tomorrow."

UPPER SHAKER LAKE, 1910. Little physical evidence of the North Union Shakers remains on the land where they lived for 67 years. Two exceptions are the lakes the Shakers created when they dammed Doan Brook. This is a view of Upper Shaker Lake (Horseshoe Lake). The Shaker Heights Land Company, which purchased the Shaker property, donated the lakes and surrounding region to the Cleveland Park Commission. (SHS.)

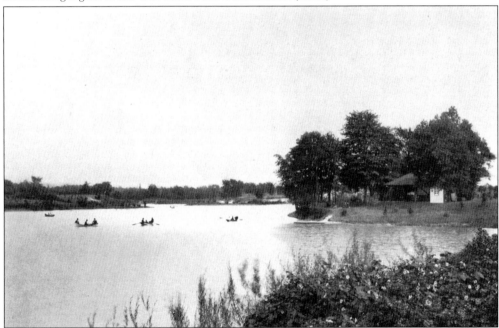

CANOEING ON LOWER SHAKER LAKE. In 1914, the City of Cleveland built a boathouse on Lower Shaker Lake. The boathouse served as headquarters for the Shaker Lakes Canoe Club, an organization that continued into the 1970s. This lake became a popular site for regattas and carnivals, with area residents lining the shores to watch the festivities. (SHS.)

STROLLING THE OLD SHAKER PROPERTY, 1900. The abandoned Shaker grounds became overgrown with brush and weeds, a site for walks by neighbors where they might come upon surprises, such as this tree, considered worthy of pausing to photograph. Here Elizabeth Hecker and Helen Kehres, elaborately dressed for their walk through the wilderness, pose for the camera. (SHS.)

OLD STONE DAM. Members of the Hecker family, who owned property adjoining the Shaker settlement, pose before ruins of the dam that created Upper Shaker Lake. Waterpower produced at this dam ran the machinery in the woolen mill. The dam had been built almost 75 years before this photograph was taken in 1900..(SHS.)

GILLETTE TAVERN. Not all the property in present-day Shaker Heights was part of the Shaker settlement. Outside those boundaries, life proceeded in more customary patterns. Here a gathering poses in front of a local landmark, the Gillette Tavern, built in 1877 and located at the corner of Kinsman (now Chagrin Boulevard) and Lee Roads. This intersection became known as Gillette's Corners. (SHS.)

KEHRES FAMILY HOME AND GENERAL STORE. Three main thoroughfares converge here: Northfield Road, Warrensville Center Road, and Kinsman (Chagrin Boulevard) Road, making this an ideal site for a general store. A blacksmith shop was located at another corner. Later this intersection became one of the busiest in the region. (SHS.)

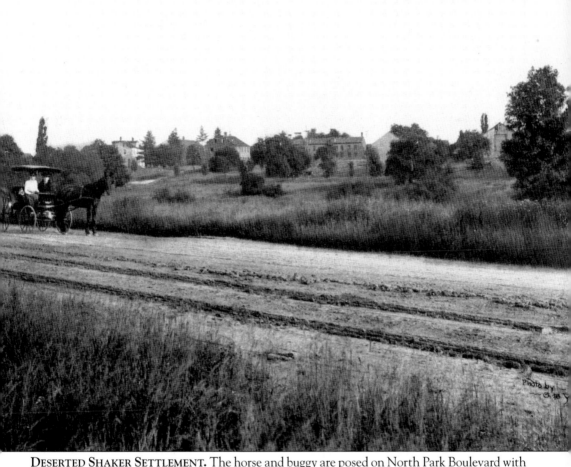

DESERTED SHAKER SETTLEMENT. The horse and buggy are posed on North Park Boulevard with abandoned Center Family buildings on the horizon. The Shaker property was sold to a group of Cleveland investors. As part of the plan for developing it, they donated a section including the Shaker Lakes and Doan Brook to the City of Cleveland for use as a park. The Cleveland Park Commission—with the help of a contribution from John D. Rockefeller—then built three roads through the park land: North Park, South Park, and East Boulevards. These roads improved accessibility to the old Shaker property, but the depression of 1893 stalled the economy. The investors sold the remaining land for $316,000 to a group of investors from Buffalo who kept the original name, the Shaker Heights Land Company. The Buffalo syndicate divided their purchase into housing lots, but the market was weak. Most of the property stood vacant, overgrown with weeds and brush. Here the land waits for what will come next. (SHS.)

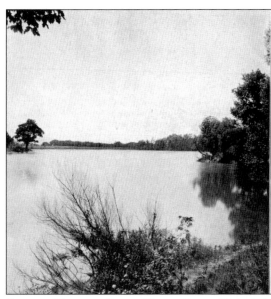

Shaker Heights

IDEAL HOME SITES

Pure Air and Water

COUNTRY SURROUNDINGS
CITY CONVENIENCES

Best Values in Suburban Property

O. C. RINGLE & CO.

Sole Agents

401-404 Society for Savings
CLEVELAND

SHAKER HEIGHTS IDEAL HOME SITES. This 1904 brochure advertises Shaker Heights as an ideal place to build a home. The photograph is of one of the Shaker lakes renamed as Crystal Lake, presumably to emphasize the allure of country living where the air and water are pure. At the time Shaker Heights was not incorporated, and much of the land offered here was in today's Cleveland Heights. (SHS.)

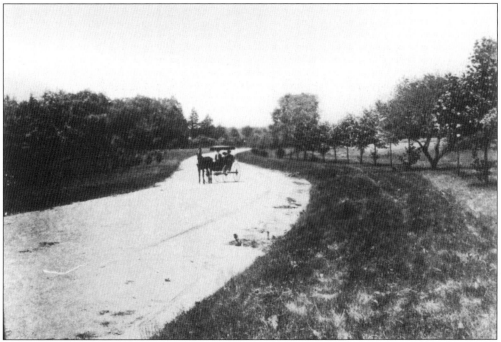

SOUTH PARK BOULEVARD. The Cleveland Park Commission created roads that cut through the old Shaker property. North Park Boulevard ran to the north of the Shaker lakes, South Park Boulevard to the south. This section of the recently constructed South Park Boulevard runs west of Lee Road and borders the old Shaker burial ground. (SHS.)

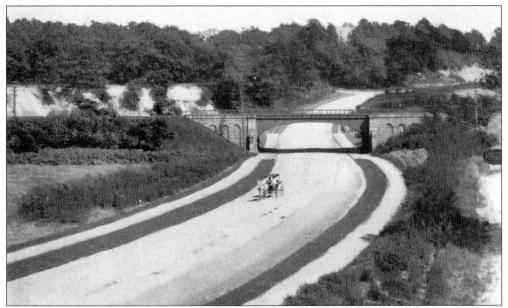

ACCESS TO SHAKER HEIGHTS. Developers emphasized the country environment of their housing lots: fresh air, clean water, open spaces. They also needed to reassure buyers that this area was not too remote from Cleveland. It was a difficult balance. One way they did this was by promoting the availability of access routes. Shown here is a wide, clear road reaching from Cleveland up into the "Heights." (SHS.)

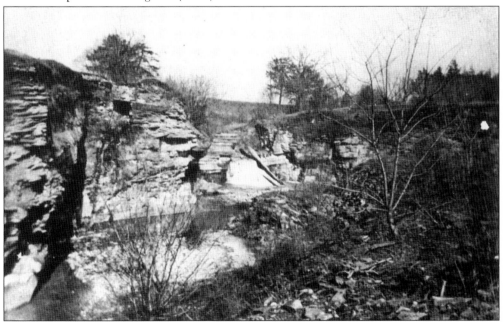

OLD DAM AND MILL RACE. The property that developers gave to Cleveland for parks has figured prominently in the fortunes of Shaker Heights. It preserved the Shaker Lakes, provided a route for access roads, and protected a large region of green space. Years later, that park land again played a crucial role when the Cuyahoga County Highway Department announced plans for freeways to run through the area. (SHS.)

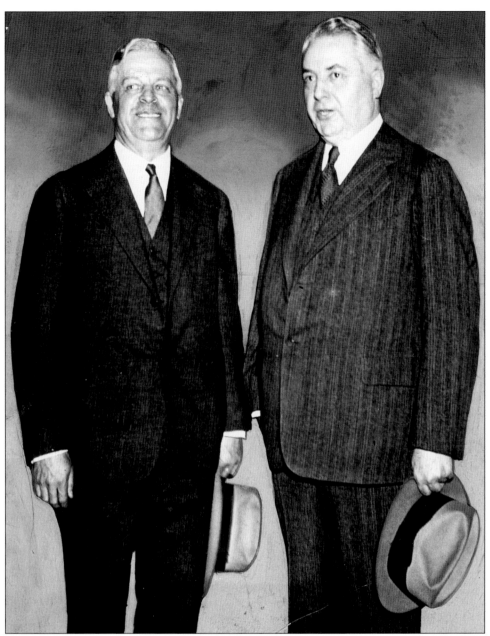

BROTHERS. Mantis James (M. J.) and Oris Paxton (O. P.) Van Sweringen were the youngest of six children born to James and Jennie Sweringen. Their father had been wounded during the Civil War and drifted from job to job, community to community, until he stopped working altogether because of alcoholism. Jennie Sweringen—exhausted by the pressures of their life—died of tuberculosis when Oris was six and Mantis was four, leaving the boys in the care of their two older sisters. Despite these tenuous beginnings, the brothers built a business empire that, at its peak, was valued at over $3 billion. The beginning of their successful endeavors and a lasting achievement was the city of Shaker Heights. While they experienced many successes, the Van Sweringen brothers also lost much of what they created. When the Van Sweringens died, much of their empire and most of their personal wealth was gone. (CSU.)

Three

ENTER THE VAN SWERINGEN BROTHERS

The Valley of God's Pleasure proved difficult to sell as housing lots; however, O. P. and M. J. Van Sweringen sensed an opportunity in this land and created one of the premier suburbs in the nation. They also assembled a railroad empire and built the skyscraper that has become Cleveland's most recognizable symbol, Terminal Tower.

The Van Sweringen brothers both quit school after the eighth grade but were not successful in their early ventures, including a bicycle shop, a butter and egg business, a stone company, and a storage operation. They had loftier dreams as indicated by their decision to change the family name from Sweringen to its aristocratic Dutch original, Van Sweringen.

Their fortunes changed when the brothers sold several lots for the syndicate that owned the old Shaker property east of Cleveland. They arranged loans to purchase the remaining land and went to work creating Shaker Heights as an exclusive community. The Van Sweringens envisioned a garden city of substantial homes that offered services demanded by prosperous residents and a school system of the highest standards.

But a problem existed: there was not convenient transportation between Shaker Heights and downtown Cleveland, so they planned a rapid transit line that would deliver commuters directly into the city. The projected route took them over tracks owned by the Nickel Plate Railroad, and in negotiations to secure permission to cross them, they unexpectedly received an offer to purchase the entire railroad. The Nickel Plate became the foundation of a railroad empire that eventually stretched across the country.

The Van Sweringen brothers were unlikely tycoons. They were intensely private men who avoided publicity, dressed conservatively in shades of gray, and were described as soft-spoken, courteous, and tactful. Neither married, they took no part in Cleveland's social life, and they were rarely seen in public. The only private vice pinned on either was O. P.'s fondness for sleep. They were also inseparable, even sharing a bedroom in their 54-room mansion.

Yet they changed Cleveland. One hundred years after they began buying property, Van Sweringen creations continue to define life in the city.

M. J. Van Sweringen. The brothers started with nothing and did whatever they could to earn money, such as newspaper routes and a succession of clerical jobs. An early effort to sell property on Cleveland's west side went bad, and they defaulted on their loan. For several years following, they did business under their sister's name while rebuilding their credit. (CSU.)

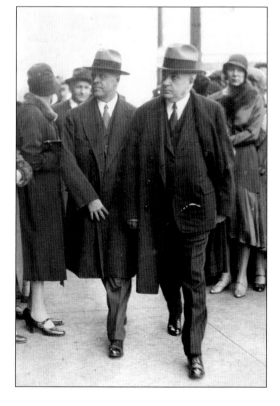

The Brothers in Cleveland. They were more successful selling properties from the old Shaker territory on Cleveland's east side. The Van Sweringens assembled a syndicate that in 1906 purchased the remaining land. They financed this transaction with loans secured by the promise of future payment but very little of their own money. They would employ this financing method throughout their careers. (CSU.)

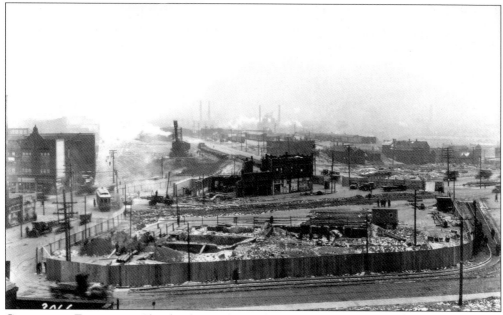

CLEVELAND FACTORIES. Cleveland roared into the 20th century as the center of the nation's oil refining and steel industries. The population quadrupled from 1870 to 1900 and by 1910 had doubled again. This dramatic growth brought wealth to some, but the industries created a cloud of pollution that hung over the city. Social unrest also threatened as immigrants poured in to seek work. (SHS.)

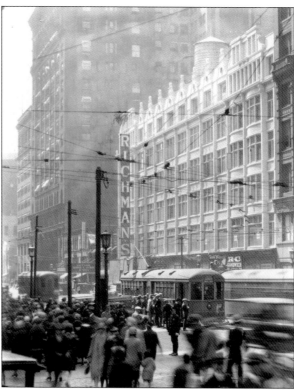

EUCLID AVENUE, CLEVELAND. Fresh in the memory of Cleveland's prosperous citizens was the fate of mansions that had lined Euclid Avenue. The area had been nicknamed "Millionaire's Row" because of the wealth of those who lived there. Unchecked growth brought in commercial establishments, and soon Euclid was not such a good address anymore. Wealthy residents would be receptive to an exclusive community that would last. (CSU.)

47

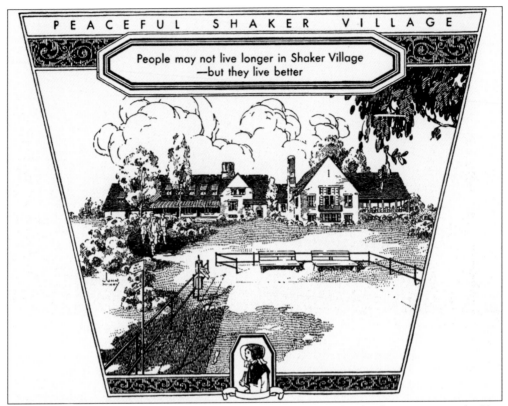

People may not live longer in Shaker Village
—but they live better

LIVING BETTER IN SHAKER VILLAGE. Not only was there a market for the community the Van Sweringens had in mind, there was also a substantial plot of undeveloped land: the old Shaker settlement and other farmland surrounding it. Furthermore, this land was well located in the "heights" above Cleveland. Here was an opportunity to build a city from scratch. (SHS.)

SHAKER INSIGNIA. The Shaker history of this land offered a marketing opportunity. Peace and serenity, fresh air, and clean water had been part of life at North Union—so too in Shaker Heights. The Shakers had sought to build the kingdom of heaven on earth. Shaker Heights would also be a kind of utopia, a community set apart from the ordinary world. (SHS.)

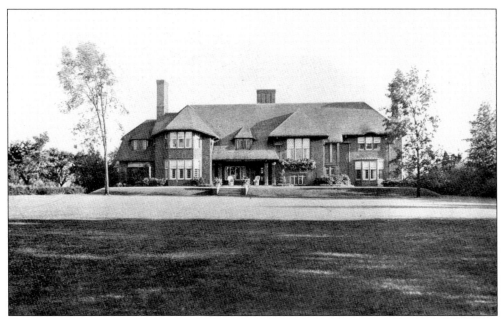

HOME FROM BROCHURE. Unlike the Shakers, though, modesty in housing or living circumstances was not part of the program. The target audience for the initial Shaker Heights offerings was made up of those who had done well in their professional lives and were ready to reap the benefits. The homes were substantial. (SHPL.)

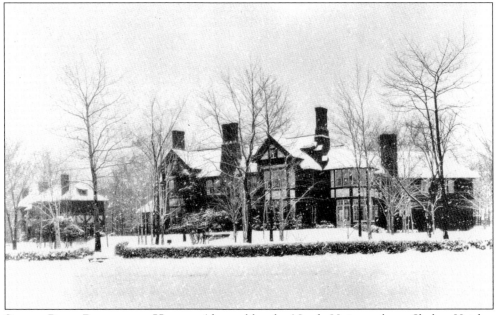

SOUTH PARK BOULEVARD HOMES. Also unlike the North Union colony, Shaker Heights was designed to be *permanent*. It was not going to close; it was not going to change. Housing contracts featured 99-year deed restrictions setting standards for how the property was to be used. To underscore the theme of permanence, the architecture of these homes was steadfastly conservative: solid, heavy, built to last, and in styles of the previous century. (SHPL.)

ORIS PAXTON VAN SWERINGEN. O. P. Van Sweringen was shy, serious, and physically slow, yet he had a brilliant mind. He could put seemingly random information into coherent patterns and find solutions to problems that stumped everyone else. He was also a visionary whose ambitions were propelled by an unfailing optimism. He was aggressive in business but reserved personally and tried to deflect attention away from himself. (SHS.)

MANTIS JAMES VAN SWERINGEN. M. J. Van Sweringen was more personable than his older brother, who could seem remote, but he did not possess a comparable intellect. He was better with details and kept O. P. on schedule when he became lost in his work. He played the role of facilitator between his brother and their associates. Both brothers were described as "soft-spoken, self-effacing men, minus conceits of any kind." (SHS.)

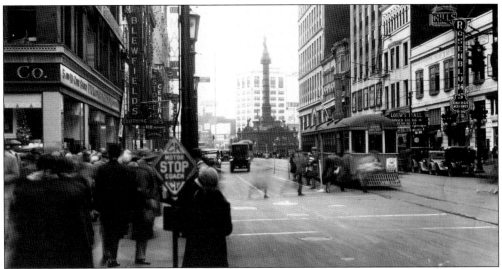

CLEVELAND STREETCARS. Transportation between downtown Cleveland and Shaker Heights was key to the success of the suburb the Van Sweringens were building. Cleveland had a well-developed system of streetcars connecting to most points in the city. However, since they shared the road with other vehicles and stopped frequently, progress could be slow. (CSU.)

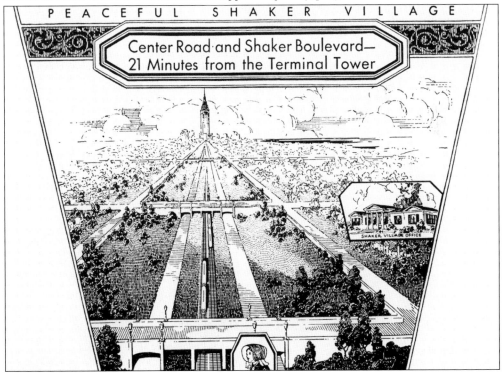

PEACEFUL SHAKER VILLAGE

Center Road and Shaker Boulevard—
21 Minutes from the Terminal Tower

SHAKER VILLAGE OFFICE

ADVERTISEMENT SHOWING TRANSPORTATION ROUTES. The Van Sweringens needed an efficient method of commuting to persuade buyers to move into what was then considered a rural area. As a first step, they convinced management of a streetcar line to extend its routes, but the journey took too long. For true "rapid" transit, they needed a train between downtown Cleveland and Shaker Heights running on its own tracks. (SHS.)

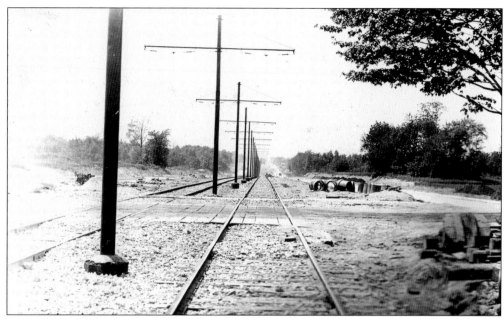

LAYING TRACKS. The Van Sweringen brothers located a route and began buying property in anticipation of laying tracks. However, their chosen rapid transit route passed over a right-of-way owned by the Nickel Plate Railroad, then controlled by the New York Central Railroad. Rapid transit trains to Shaker Heights could not cross that property without permission from the New York Central. This photograph shows the tracks along Shaker Boulevard in 1914. (SHS.)

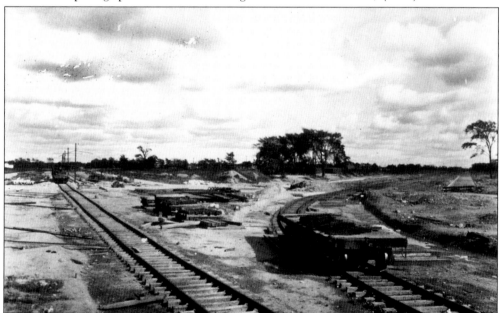

SHAKER RAPID UNDER CONSTRUCTION. The Van Sweringens met with the New York Central president, who advanced a surprising proposal. Instead of permission to cross Nickel Plate tracks, he offered the whole railroad. The New York Central was under pressure to divest itself of that line, and the Van Sweringens would be friendly competitors. They agreed to buy the Nickel Plate Railroad with loans and—as always—very little of their own money. (SHS.)

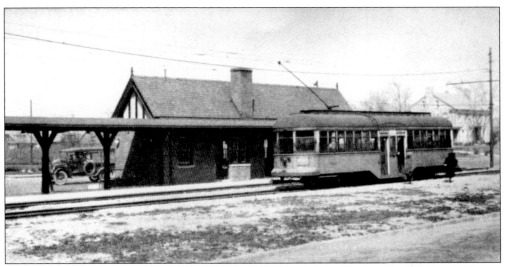

SHAKER RAPID AT COVENTRY STATION. Construction of the Shaker Heights Rapid Transit proceeded with full service commencing in 1920. Now Shaker Heights residents could make the trip downtown in an unprecedented 21 minutes. The major stations—Coventry and Lynnfield—offered services to riders including a coffee shop, newsstand, drugstore, and soda fountain. (SHPL.)

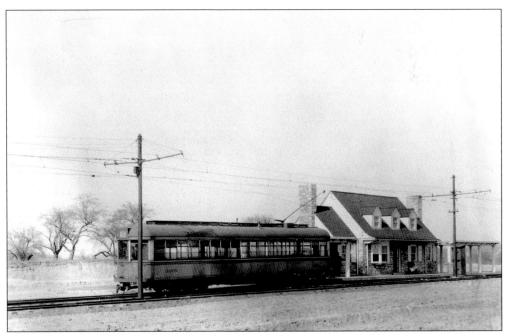

SHAKER RAPID AT LYNNFIELD STATION. The tracks were built in advance of construction in an area so that transportation would be available when housing reached it. The Lynnfield station was originally the end of what would become the Blue Line. In this photograph from the 1920s, the station stands alone on a landscape without the buildings that later surrounded it. (SHPL.)

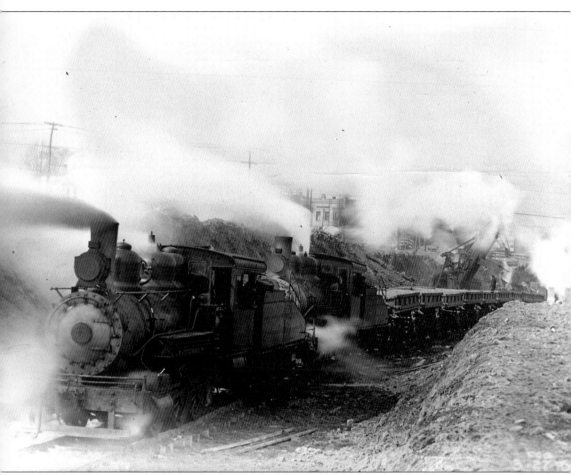

SHAKER BOULEVARD UNDER CONSTRUCTION. As work on the rapid transit line continued, streets for Shaker Heights were also laid out. Plans created by the F. A. Pease Engineering Company called for major new roads to parallel the tracks: Shaker Boulevard and Moreland Boulevard (now Van Aken Boulevard). Side streets were also planned in relationship to the transit system. They converged at regular intervals along the two major roads. This design minimized the number of rapid transit stations needed and therefore the number of stops the trains needed to make along their routes. Excavation for Shaker Boulevard is seen here. (SHS.)

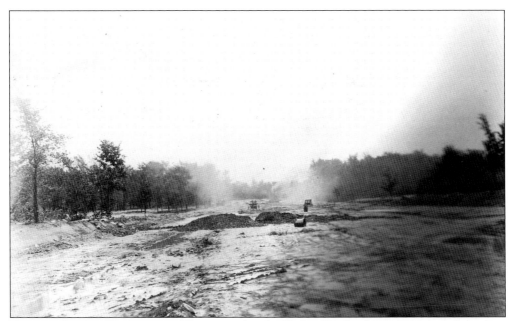

EAST ON SHAKER BOULEVARD. The street plan for Shaker Heights kept existing roads, such as Kinsman (Chagrin Boulevard), South Woodland, and Lee Roads, in place. Other roads were constructed on land that had been mostly wilderness. This view is of initial grading for Shaker Boulevard looking east from about where Fontenay Road is today. This location is just north of the old East Family buildings of the North Union Shakers. (SHS.)

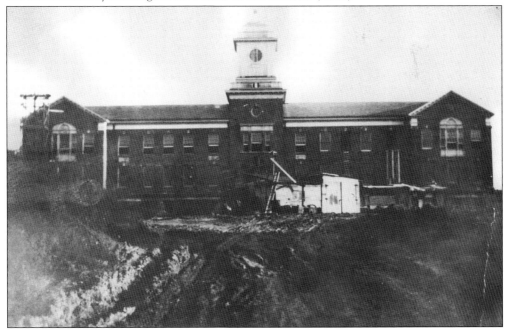

HIGH SCHOOL UNDER CONSTRUCTION. Shaker Heights was not just to be a housing development, it was a total planned community. The Van Sweringens set aside land for parks, churches, country clubs, and both public and private schools. Here the original Shaker Heights High School (now Woodbury Elementary School) nears completion. (SHS.)

SHAKER HEIGHTS VILLAGE HALL. This structure was located on the northeast corner of Lee Road and Shaker Boulevard and served as real estate offices for the Van Sweringen Company. The company made space available in this building for Shaker Village offices and for classes of the new Shaker Village schools. The old Shaker meetinghouse had been located near this site. (SHPL.)

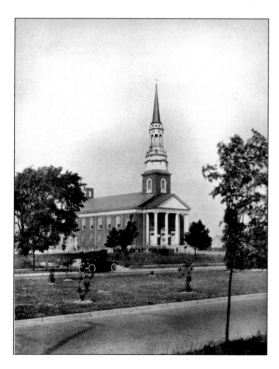

COMMUNITY CHURCH. The Van Sweringens reserved plots for use by churches. The first, identified in a sales brochure as the Community Church, was established in 1916 when the Plymouth Society moved from Cleveland to Shaker Heights. This building was designed in the style of a New England church and first used in 1923. Today it is Plymouth United Church of Christ. (SHS.)

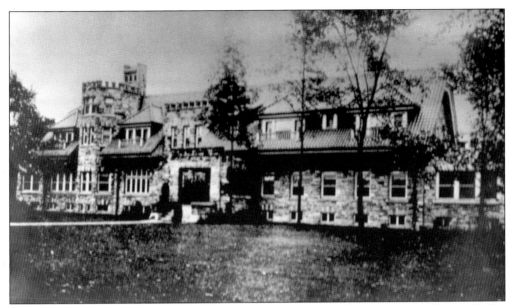

VAN SWERINGEN SHAKER HEIGHTS HOUSE. The brothers built themselves a mansion in Shaker Heights on what was then a large tract of wooded land. This photograph shows the house in its original form before remodeling added Tudor features to the exterior. O. P. and M. J. lived here together with their two unmarried sisters. Their older brother, Herbert, lived on Sedgewick Road with his family. (SHS.)

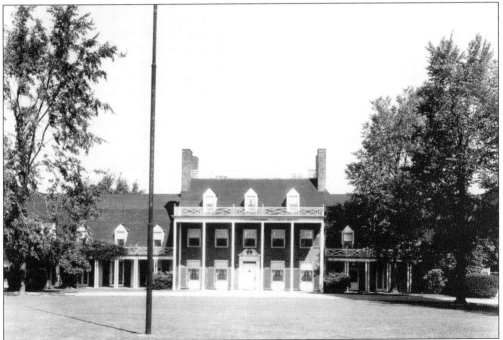

DAISY HILL. The brothers later purchased an old farm in Hunting Valley and converted its primary buildings into a 54-room mansion they called Daisy Hill. After the stresses of a day, they would be driven home from their downtown offices to relax at their country estate—but always after visiting their sisters, who now had the Shaker Heights mansion to themselves. (CSU.)

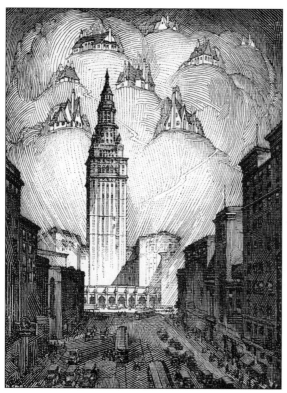

UNION TERMINAL AND TERMINAL TOWER. Cleveland's need for a modern railroad terminal created another possibility for the Van Sweringens. They planned a massive union station to be shared by several railroads and the Shaker Heights Rapid Transit with the tower becoming a new focus for downtown Cleveland. This illustration depicts the Union Terminal Tower with Shaker Heights homes hovering in the cloudlike hills above the busy, noisy city. (SHS.)

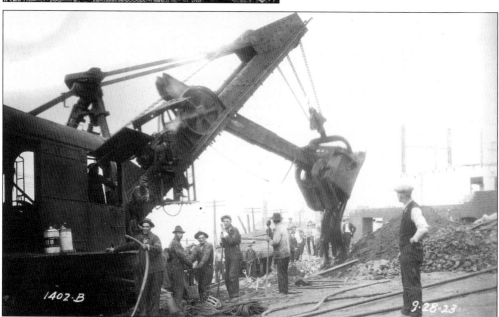

CONSTRUCTION BEGINS ON UNION TERMINAL. When the brothers purchased the Nickel Plate Railroad, they did not stop at one railroad. They bought more—including the Chesapeake and Ohio, the Erie, the Lackawanna, the Lehigh Valley, and the Missouri Pacific—until they owned or controlled 29,431 miles of track: the nation's largest railway system under single control. This photograph records the start of construction for Union Terminal in 1923. (SHS.)

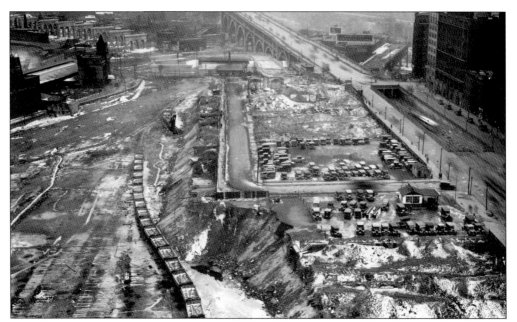

CONSTRUCTION SITE, UNION TERMINAL. Cleveland's city plan called for a railroad terminal to be built near the Lake Erie shore where most railroad tracks were already located. The Van Sweringens convinced city officials and voters to accept an alternate site on Public Square, then a dilapidated section of the city. To build the terminal, 35 acres of land were cleared, 2,200 buildings demolished, and 15,000 people relocated. (CSU.)

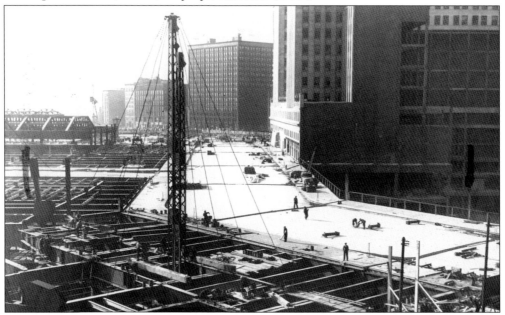

LAYING THE FOUNDATION. Plans for Union Terminal called for a "city within a city" that included offices, a hotel, and a department store. When the Van Sweringens could not convince a flagship store to occupy the facilities, they bought one: Higbee's. The brothers' unique genius was in finding ways to finance their massive purchases and projects. They created over 250 interlocking holding companies for this purpose. (CSU.)

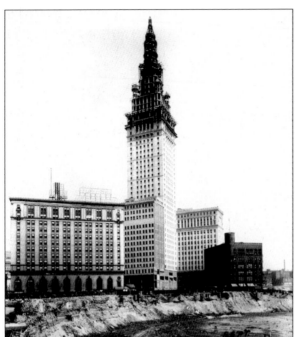

THE TOWER NEARING COMPLETION. Terminal Tower was the second-tallest building in the world when it opened in 1930. The Van Sweringens used the same conservative style of building that characterized Shaker Heights. It was solid and massive with little in the way of modern touches. This was a building for the ages, and Clevelanders felt a rush of uncharacteristic community pride at the sight of their new landmark. (SHS.)

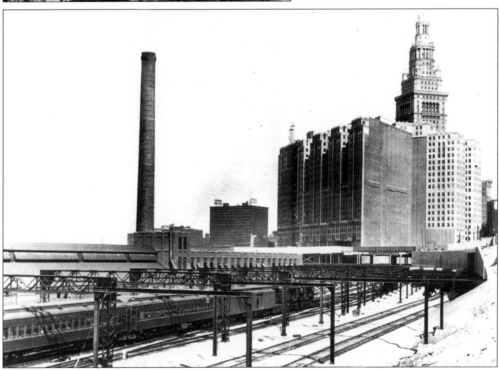

NICKEL PLATE TRACKS ENTERING TERMINAL. Union Terminal provided a station for the railroads, a destination for the Shaker Heights Rapid Transit, and a skyscraper for Cleveland as well as a massive concentration of new office and retail space. The center of retail and commercial activity in Cleveland, which had begun to drift east, was now firmly reestablished downtown. (SHS.)

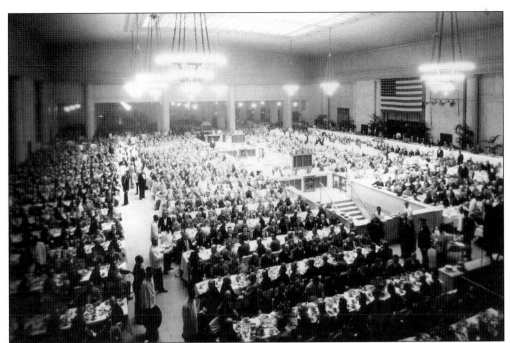

UNION TERMINAL OPENING. A crowd of 2,500 celebrated the opening on June 28, 1930, but the Van Sweringens, uncomfortable with public acclaim, did not attend—they listened on the radio from home. It was a grand day, but as service commenced from Union Terminal, the peak of American railroading had already passed. In 1922, a total of 94 trains left Cleveland daily. By 1932, that number dropped to 78 daily departures. (SHS.)

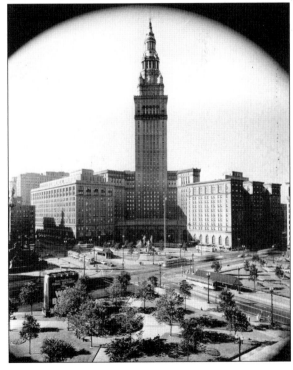

UNION TERMINAL. The Union Terminal complex was the last great achievement of the Van Sweringens. Even as it neared completion, the Van Sweringens' empire was falling apart. Their projects were financed on borrowed money with payment dependent on income generated by the acquisitions. When the American economy faltered in the 1930s, stock values plummeted, and income from Van Sweringen properties was no longer sufficient to cover the payments. (SHS.)

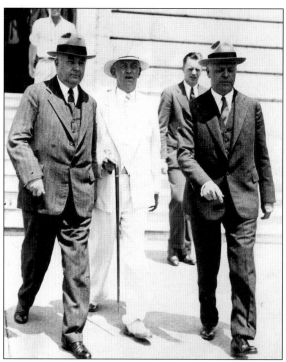

THE BROTHERS IN WASHINGTON, D.C. As the American banking and railroad systems verged on collapse, Van Sweringen companies struggled to remain solvent. The brothers traveled to Washington, D.C., to testify before the Senate Banking Committee for its investigation of banking and holding company practices. Regulations that tightened financing procedures resulted, but O. P. and M. J. returned home with the more immediate challenge of saving their businesses. (CSU.)

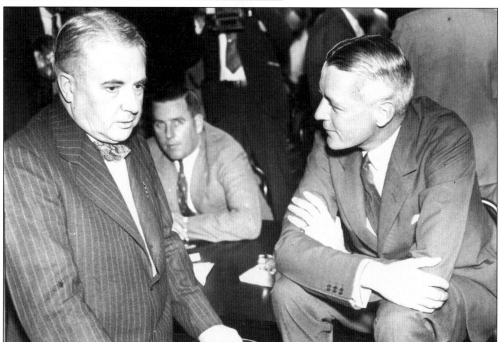

O. P. VAN SWERINGEN AT SENATE HEARINGS. In September 1935, Van Sweringen holdings valued at almost $50 million were put up for sale by creditors. In a final remarkable feat, the brothers—with the help of backers—bought back their businesses for a fraction of what they owed. Afterward, a pale O. P. Van Sweringen said, "I'm sorry it had to be done this way. I'd rather have paid the bills." (CSU.)

An Exhausted M. J. Van Sweringen. The brothers had positioned themselves for a comeback, but exhausted by the long struggle, M. J. fell ill and died of heart failure on December 12, 1935, with O. P. at his bedside. He was 54 years old. At his death, M. J.'s personal estate was valued at $3,067, which he left to his brother. (CSU.)

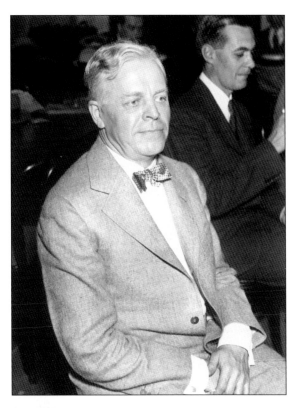

O. P. Van Sweringen Continues Alome. O. P. was bereft at his brother's death. Each morning he turned on the light on M. J.'s desk; each evening he turned it off. Many believe O. P. would have been successful in rebuilding the businesses, but he died at age 57 on a train in New Jersey just 11 months after M. J. had died. (CSU.)

Auction at Daisy Hill. The Ship Room was the largest at the Van Sweringens' Daisy Hill mansion, remodeled from a barn hayloft and measuring 40 feet by 80 feet. After the Van Sweringens died, it hosted an auction of over 3,000 possessions to cover some of their debts. The wealthy and the curious thronged to the sale to catch their personal glimpses of the Van Sweringen story. (CSU.)

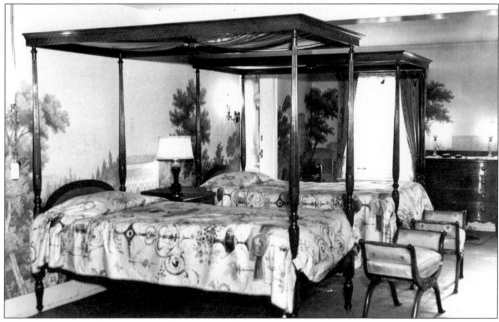

The Brothers' Bedroom. The Daisy Hill mansion was set on 500 acres of rolling land, landscaped as a park and resembling an English feudal estate. Despite the lavishness of these surroundings, O. P. and M. J. continued to share a simple bedroom, as they had since childhood. They had started together with nothing, built an empire valued at over $3 billion, and then—still together—saw it collapse. (CSU.)

VAN SWERINGEN GRAVESTONE. O. P. and M. J. Van Sweringen share a plot in Cleveland's Lake View cemetery. It is an environment of impressive monuments, including the tomb of assassinated U.S. president James A. Garfield and a tall obelisk marking the final resting place of John D. Rockefeller. By contrast, the marker at the Van Sweringen grave is modest: a stone at ground level that reads "Brothers."

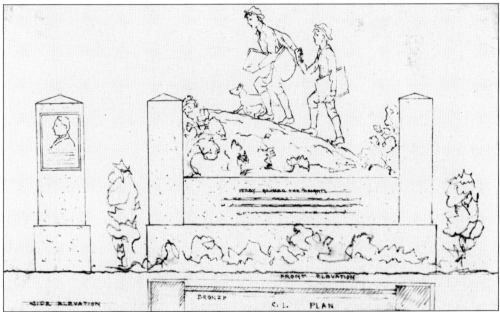

UNBUILT MEMORIAL. Two boys carrying newspapers climb a hill in a design created by sculptor Frank L. Kirouch in 1956. It reads, "They climbed the heights." The memorial was not built. Today there are no memorials and little official recognition of the Van Sweringens in Shaker Heights or throughout Greater Cleveland. (CSU.)

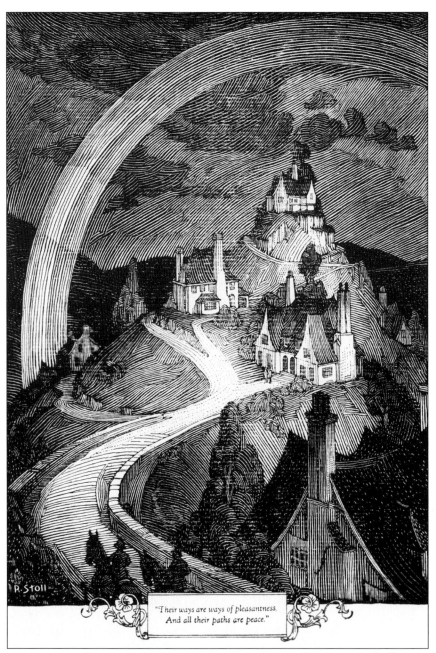

"Their ways are ways of pleasantness,
And all their paths are peace."

AT THE END OF THE RAINBOW. Unlike most towns and cities that grow gradually in response to the needs and demands of residents, Shaker Heights was planned from the beginning as a complete entity: homes, parks, schools, churches, country clubs, municipal government, shopping. The Van Sweringen Company claimed that this was the largest residential development under single control in the world. Here was a vast experiment in creating the ideal environment for human well-being, a modern utopia. This illustration, taken from a sales brochure, shows travelers returning from the darkness below, up into the light and warmth of their homes. What was the reward at the end of the rainbow? Not a pot of gold but "contentment, peacefulness, the beauty of nature and of wise planning, forever assured by protective restrictions." (SHS.)

Four

CREATING
SHAKER HEIGHTS

The Van Sweringens spent years on the design for Shaker Heights before offering properties for general sale. From the beginning, this was not just a housing development. It was a planned community creating a quality of life that set Shaker Heights apart.

The design of Shaker Heights was guided by ideals of the garden city movement that originated in England and advocated communities with extensive parks and both public and private gardens. In a garden city, population density was controlled so that residents had a sense of open space throughout their community. Streets were lined with trees, schools were placed on large plots surrounded by green space, and houses were set back to create substantial front lawns.

The architecture of homes and public buildings in Shaker Heights was also controlled. Homes were to be designed by an approved architect and conform to styles and standards established by the Van Sweringen Company. The acceptable designs for Shaker Heights houses were profoundly traditional. At a time when artists and architects were experimenting with the modern, Shaker Heights looked firmly backward to styles of the previous century. These homes offered a sense of comfort, reliability, and permanence. Buyers were assured that their investment in Shaker Heights was secure, not just because of the quality of the housing but also due to 99-year deed restrictions that promised to keep things as they are, always.

Included within the planning were municipal services and amenities that buyers expected. The Van Sweringens provided for a public school system and also several private schools. Retail stores were initially not allowed in Shaker Heights; it was to be strictly a city of homes. The need for a shopping area was addressed by developing Shaker Square in a section originally part of Shaker Heights but then ceded to Cleveland. Land was also set aside for churches and country clubs.

Advertising for Shaker Heights related back to the Shakers who had once lived on this land. As theirs was a refuge from the outside world and its harshness, so was Shaker Heights.

THE HERITAGE OF THE SHAKERS. Judging by its cover, this booklet appears to promise a historical view of the Shakers in a centennial year of 1923. In fact it is a brochure published by the Van Sweringen Company advertising houses for sale in Shaker Heights. Promotional materials often drew upon the "heritage of the Shakers" to emphasize that this community was, like the Shakers, set apart from the world. (SHPL.)

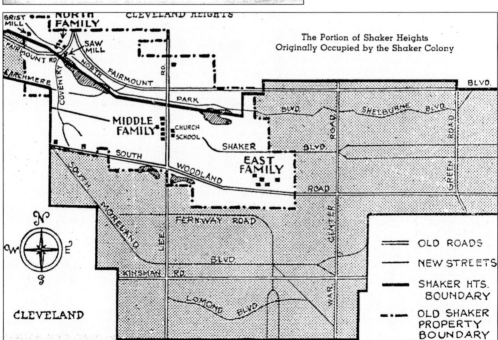

SHAKER HEIGHTS BORDERS. The initial boundaries of the village of Shaker Heights were fluid, sometimes expanding, sometimes shrinking. When a portion of Shaker Heights was returned to Cleveland for Shaker Square, the odd extension on the northwest corner was retained because Mayor William Van Aken's property was located there. This map shows present-day borders of Shaker Heights in relationship to North Union Shaker land. (SHS.)

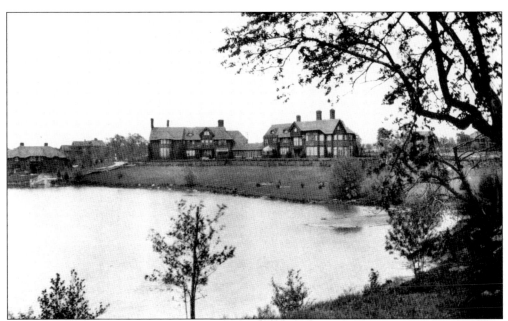

MARSHALL LAKE. Developers retained the two lakes the Shakers had created when they dammed Doan Brook. They added two more: Marshall Lake and Green Lake. This photograph is a view of Marshall Lake with two adjoining homes built for the owner of a drugstore chain, W. A. Marshall, and his son. It was included in the sales brochure "The Heritage of the Shakers." (SHPL.)

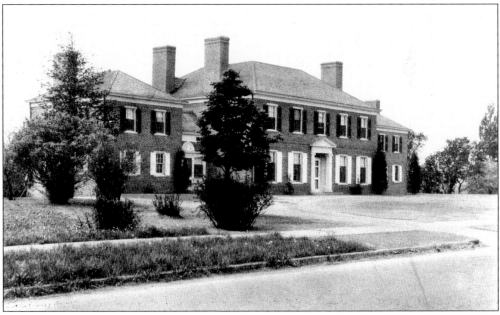

NEWTON D. BAKER HOME. This house on South Woodland Road was home to Newton D. Baker, Woodrow Wilson's secretary of war, Cleveland's law director, and a contender for the Democratic nomination for president that went to Franklin Delano Roosevelt. Plans for Shaker Heights included mansions like this for high-profile residents as well as housing for families of more modest means. (SHPL.)

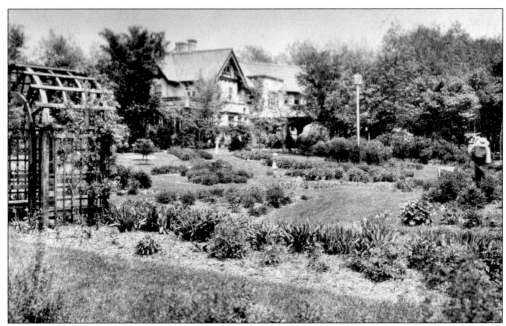

A Garden City. The Van Sweringens were influenced by the English concept of a garden city with ample green space throughout. Homes were set back from the street to create large front yards; thus, private property contributed to the public experience of the community. A garden city offered a sense of peace and serenity where residents benefited from the best of city and country living. (SHS.)

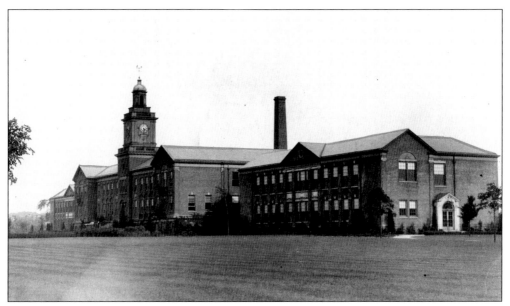

Public Buildings in a Garden City. Public buildings contributed to the experience of open space by their placement on large plots of landscaped property. Houses were also set back from the roads, conveying an expansiveness that carried throughout the community on both public and private property. Pictured here is the original Shaker Heights High School (now Woodbury Elementary School) and its sweeping front lawn. (CSU.)

PARKLAND DRIVE. The Van Sweringens engaged the F. A. Pease Engineering Company to create the layout for Shaker Heights. Placement of roads through the city was an important factor in creating the desired atmosphere: main arteries were straight and wide to promote their use, residential streets curved making them aesthetically more pleasing as well as inconvenient to cut through, thus diminishing the traffic. (SHS.)

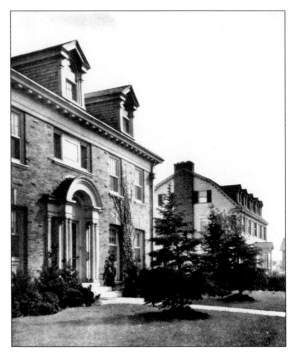

BROXTON ROAD HOMES. The F. A. Pease Engineering Company sent one of its partners, H. C. Gallimore, to England to study garden cities and bring back ideas to apply to Shaker Heights. Gallimore was a student of English literature, and he drew from that knowledge—as well as from an English postal directory—to name roads in Shaker Heights. (SHPL.)

MAY M. CHAPMAN. A recent graduate of Columbia University, May M. Chapman came to Shaker Heights in 1912 to serve as the school system's first principal. She expressed her enthusiasm for helping develop schools "where individual progress would be the first consideration." During the four years of her tenure, enrollment in the Shaker Heights schools grew from 26 pupils to 169. (SHCS.)

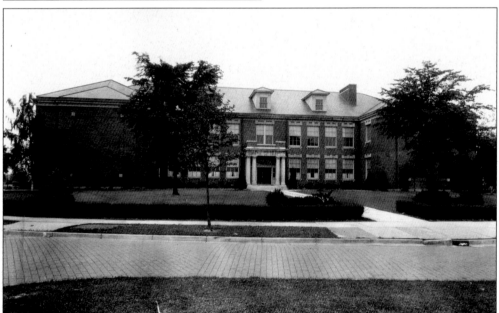

BOULEVARD SCHOOL. The first classes of Shaker Heights schools were held in the village hall. Shaker Boulevard School, now known as Boulevard School, was completed in 1914 and hosted classes for 1st through 12th grades. From the beginning, the schools offered innovative approaches to education such as "a special teacher for those needing extra attention." In 1917, the board of education added a requirement, unusual for its time, that teachers be college graduates. (SHPL.)

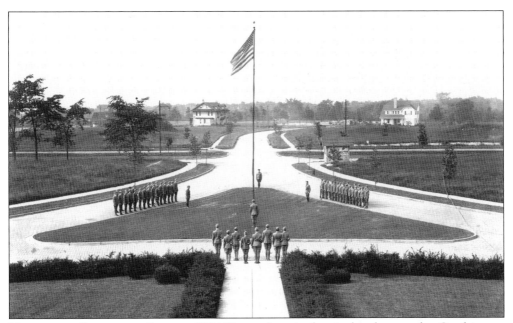

NORTH FROM BOULEVARD SCHOOL, 1917. The roads are in place in this photograph—Southington and Drexmore Roads come together at Shaker Boulevard, and rapid transit tracks have been laid. Only a few houses are visible, but in the distance is construction on another home. Newly planted trees line the streets, and the roads are brick. On the triangle in front of Boulevard School, students in military uniform raise the flag. (SHS.)

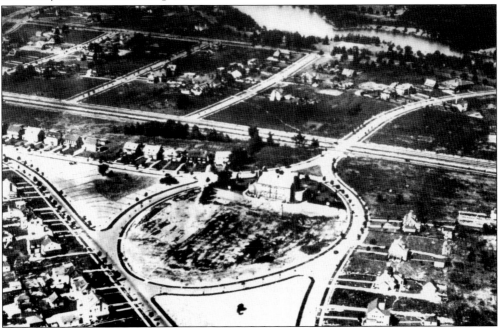

BOULEVARD SCHOOL NEIGHBORHOOD, 1920. An aerial view shows houses beginning to fill the landscape, but there is still significant open space, such as in the oval where the school is located and the two triangular areas on either side of the oval. These were to be left undeveloped—open and green—as houses were built in the surrounding area. To the north is Lower Shaker Lake. (SHPL.)

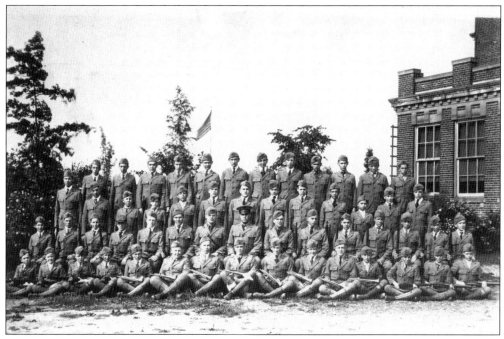

MILITARY TRAINING UNIT, 1918. As American forces became involved in the war in Europe, German-language instruction was removed from the curriculum and military training made compulsory for boys sixth grade and up. The boys in this military training unit are posed next to Boulevard School. Some are holding bugles, others have rifles. After the war, German returned to the curriculum, and military training was dropped. (SHS.)

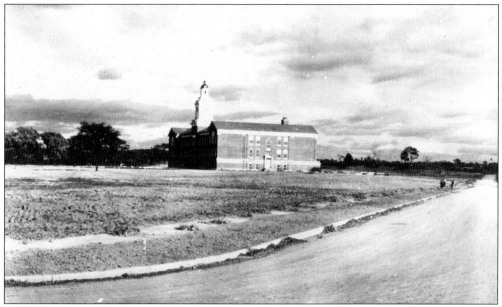

SHAKER HEIGHTS HIGH SCHOOL. Boulevard School served all grades until 1919 when the high school was completed. Here the new building can be seen from the intersection of South Woodland and Woodbury Roads, then brick streets. The trees that line Woodbury Road have not yet been placed, and no landscaping has been done on the school grounds. (SHS.)

HIGH SCHOOL VIEWED FROM EAST. The first levy to support Shaker Heights schools was placed before voters in 1912. It passed with 20 of the 25 votes cast in favor. A 1938 publication of the board of education noted that Shaker Heights schools spent more per pupil than any district in the area. Shaker schools became known as "private schools with public funding." (SHS.)

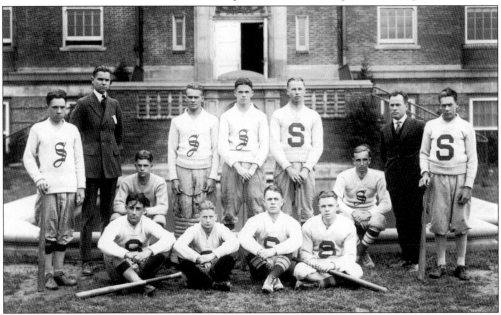

HIGH SCHOOL BASEBALL TEAM. Athletics played an "important but sane" role in the Shaker Heights schools, according to a board of education brochure. The board furnished basketballs and baskets to students before the first school building was constructed, and an athletic coach was hired when Boulevard School opened in 1914. Here the baseball team in 1919 poses in front of the new high school building. (SHS.)

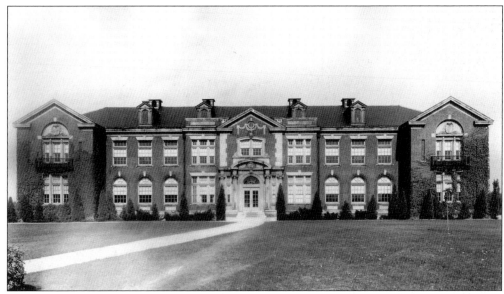

ONAWAY SCHOOL. The Shaker Heights school system built 10 school buildings in 17 years. This included the complex that comprised the old high school (now Woodbury School), Onaway School in 1923, and the current high school in 1931. These facilities were laid out on abundant lawns with tennis courts, fields for hosting sports events, and the community rose garden. (SHPL.)

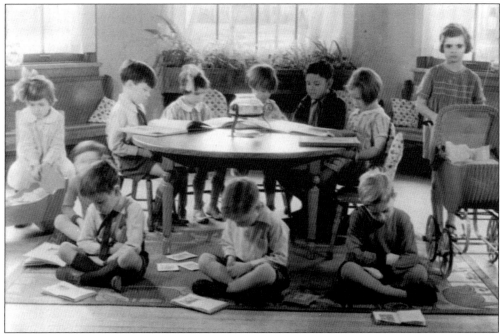

LUDLOW SCHOOL PUPILS, 1931. The school board encouraged teacher freedom and creativity by eliminating administrative tasks and rigid schedules. Instead, teachers were encouraged to bring their best skills to the classroom—and in the process encourage a comparable freedom and creativity in their students. Teachers who developed successful innovative approaches shared these with others on the staff, working together to create a dynamic environment for learning. (SHPL.)

VISITING THE MUSEUM OF ART. From their inception, Shaker Heights schools taught students more than the fundamentals of reading, writing, and arithmetic. They also called for "development of appreciations and understanding of things of beauty and social significance." Enrichment experiences such as art classes, music instruction, and field trips were included as part of the curriculum. In this photograph, students visit the Cleveland Museum of Art. (SHCS.)

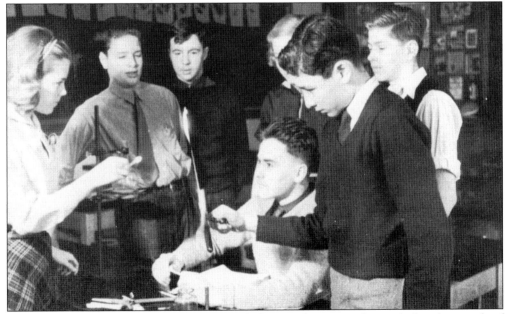

DISCOVERING COAL GAS. Education in the Shaker Heights system featured a hands-on style of learning that encouraged participation and direct experience. The students learned by doing. Here a junior high school science class experiments with coal gas. The enrollment in Shaker Heights schools had grown to 4,200 when this photograph was taken in 1938. (SHCS.)

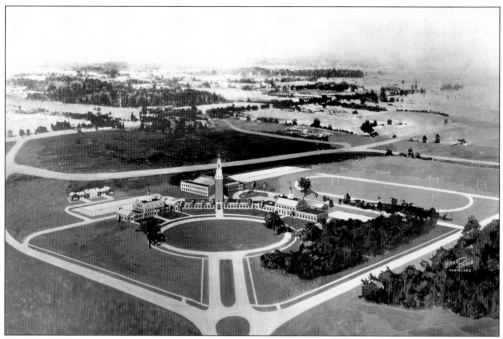

UNIVERSITY SCHOOL RENDERING, 1928. The Van Sweringen Company reserved land for three private preparatory schools in Shaker Heights. University School, a school for boys founded in 1890, established its campus in Shaker Heights. Hathaway Brown School and Laurel School, both girls' schools dating back to the late 1800s, also built facilities in Shaker Heights during the mid-1920s. (CSU.)

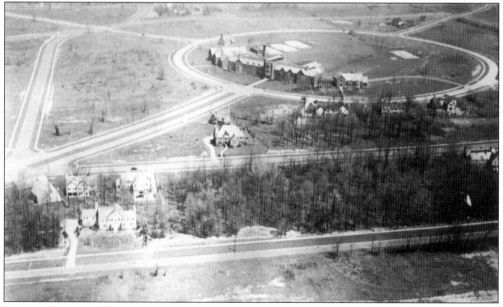

LAUREL SCHOOL. The institutions serving the community—schools and churches—were often established in advance of other settlement in the area. Here the Laurel School campus is seen with most of the surrounding area still vacant. In the years following, housing filled in the open space shown here. (CSU.)

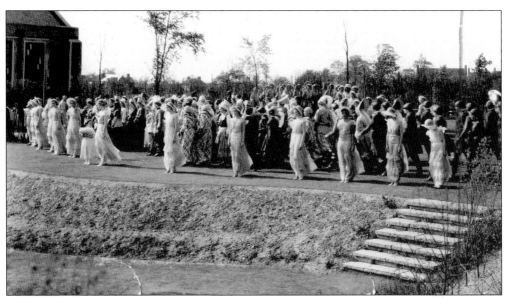

HATHAWAY BROWN MAY QUEEN COURT. Hathaway Brown School traces its history to 1876 when "afternoon classes for young ladies" were initiated in Cleveland. The private day school opened its facilities in Shaker Heights in 1927. In this 1931 photograph, the Hathaway Brown May Queen and her court appear on the school's outdoor stage. (CSU.)

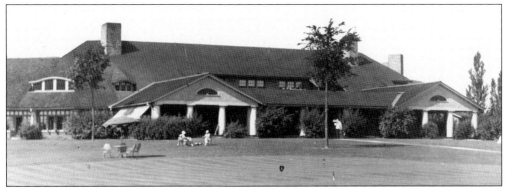

SHAKER HEIGHTS COUNTRY CLUB, 1928. The Van Sweringens provided amenities in Shaker Heights to attract those they hoped would buy homes in this community. The Shaker Heights Country Club opened in 1915 on land donated for that purpose. Property was also made available for the Canterbury Country Club. (CSU.)

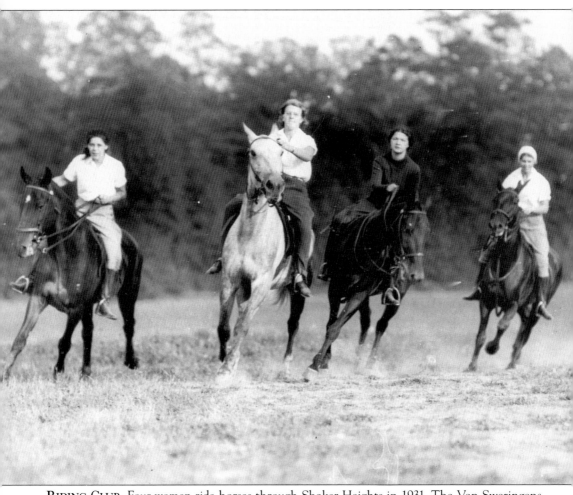

RIDING CLUB. Four women ride horses through Shaker Heights in 1931. The Van Sweringens established a riding club, and bridal paths crossed through the community. The availability of horses not only provided another service to residents but also underscored the message that this was a rural area, far from the pressures of the big city. A move to Shaker Heights was a move to the country, and early residents reported that their friends thought they were crazy to move so far away. (SHPL.)

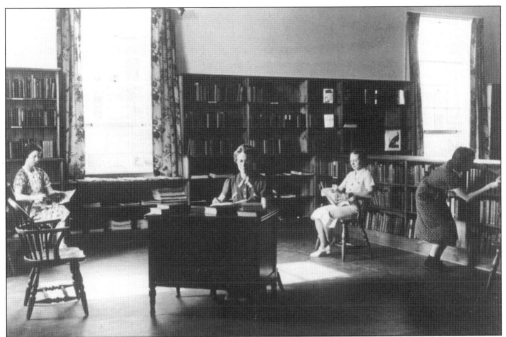

SHAKER HEIGHTS PUBLIC LIBRARY. The library had its beginnings in 1922 when a room in Boulevard School was set aside for that purpose. In 1937, the board of education created a school district library that moved into newly constructed quarters on Lee Road. This photograph shows the library staff and patrons soon after moving into the new facilities, which were designed to feel comfortable, like a living room. (SHPL.)

LEE ROAD LIBRARY. In 1951, a new building was completed that served for over 40 years until the library moved to the former Moreland School building. This building then became the Shaker Heights Community Center. The Bertram Woods branch was named after a railroad engineer whose will left assets to whatever library served his home farm, which had been located near Warrensville Center Road and Fairmount Boulevard. (SHPL.)

MAYOR WILLIAM J. VAN AKEN. As boys, William Van Aken and the Van Sweringen brothers were newspaper carriers together, delivering the *Cleveland Leader*. Later the three were close associates in developing Shaker Heights. William Van Aken became mayor in 1915, an office he held until his death in 1950. (SHPL.)

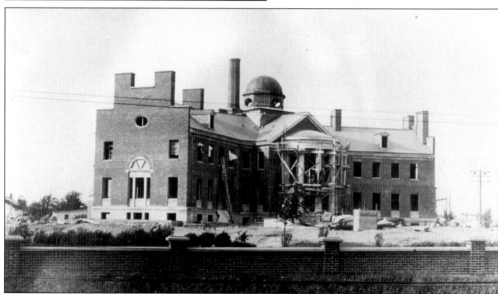

CITY HALL UNDER CONSTRUCTION, 1930. The design of public buildings—government offices, schools, and churches—was consistent with the architecture of the houses. As houses in a neighborhood were to fit together, the public buildings were to be suitable for the neighborhoods where they were located. The architect for city hall was Charles S. Schneider, who also designed Plymouth United Church of Christ and the rose garden. (SHPL.)

CITY HALL FRONT ENTRANCE.
Shaker Heights was still officially
a village when the new structure
to house local government offices
was built. But village officials were
confident of continued growth,
inscribing the term "city" in stone
over the front entrance before it
was actually true. Fortunately, the
subsequent census showed that
the village of Shaker Heights had
reached a sufficient population to be
designated a city. (SHPL.)

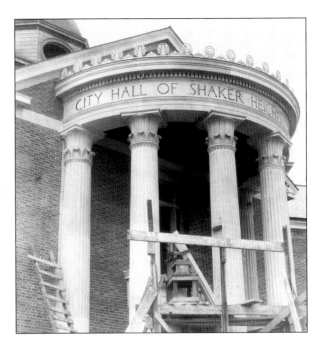

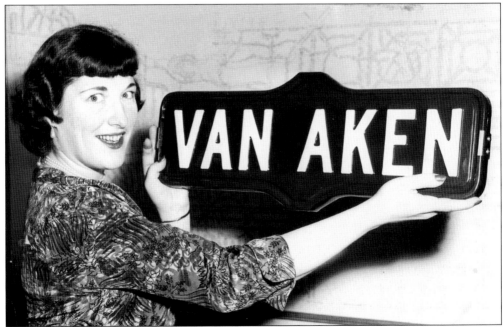

VAN AKEN BOULEVARD. After Mayor Van Aken died, Moreland Boulevard was renamed in his
honor. Displaying the sign announcing the new name in this 1951 photograph is Julie Krausslich,
secretary to the mayor. Van Aken and Shaker Boulevards are the two main thoroughfares
planned by the Van Sweringens to parallel the rapid transit tracks. (SHPL.)

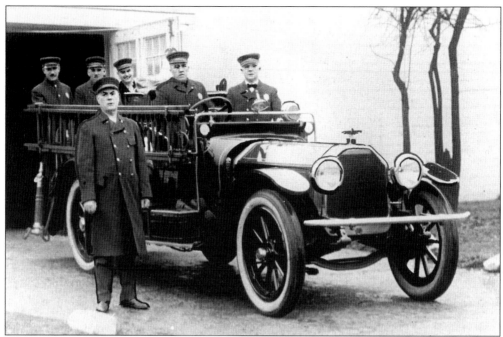

FIRE DEPARTMENT. As the village developed, municipal services were added. The first police department consisted of a single village marshal hired in 1912. A fire department was added in 1917 with eight paid firemen and a truck. In 1922, members of the Shaker Heights Fire Department pose for this photograph. (SHPL.)

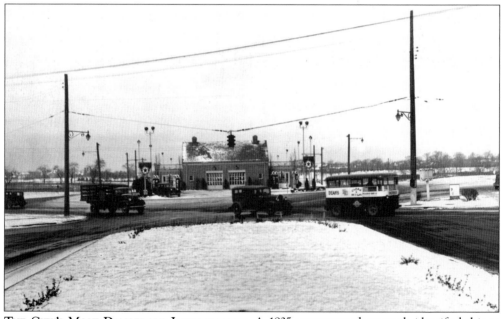

THE CITY'S MOST DANGEROUS INTERSECTION. A 1935 newspaper photograph identified this as the most dangerous intersection in Shaker Heights where Kinsman (now Chagrin Boulevard), Warrensville Center, and Northfield Roads come together. The photograph shows one traffic light regulating the flow of traffic. Today it takes 20 sets of lights to do what this one did in 1935. (CSU.)

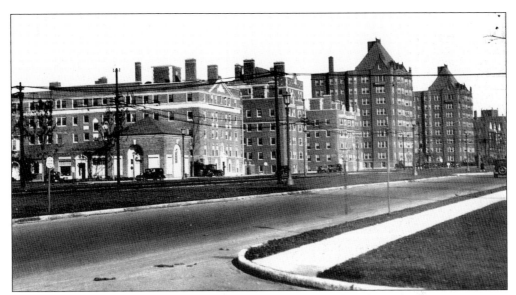

MORELAND COURTS. In 1922, a local entrepreneur, Josiah Kirby, planned a luxury apartment complex around Moreland Circle, a rapid transit junction. The idea was to include offices and shopping in addition to upscale apartments designed with an Old English theme. The plan received approval from the Van Sweringen brothers, and construction began on the first apartment unit located on Shaker Boulevard, west of Moreland Circle. (CSU.)

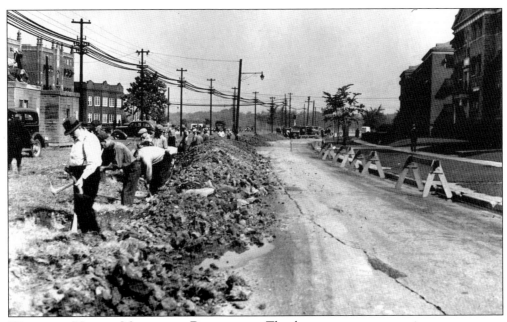

WIDENING NORTH MORELAND BOULEVARD. The luxury apartment project came to an abrupt halt when Josiah Kirby went bankrupt. The project was dormant for five years until the Van Sweringens took it over, resuming construction on the apartment buildings—Moreland Courts—planning a new shopping area around Moreland Circle, and reconfiguring its roads. (CSU.)

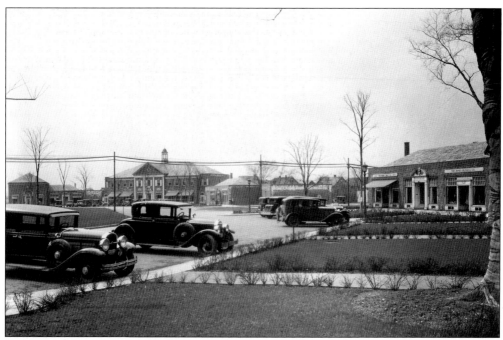

SHAKER SQUARE. Most of this development was within the boundaries of Shaker Heights, then restricted to residential use. The Van Sweringens returned a section of Shaker Heights to the City of Cleveland and created Shaker Square as a commercial district, one of the first shopping centers in the nation. (SHPL.)

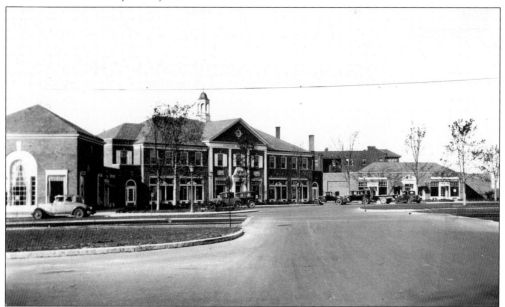

SHAKER SQUARE, 1929. To create this shopping district, Moreland Circle was "squared," becoming a New England–style town green with four quadrants of shops designed with Georgian-style architecture. The Shaker Heights Rapid Transit ran through it, providing a link both to downtown Cleveland and the eastern suburbs. O. P. Van Sweringen took particular interest in this project, turning to it for a break from the demands of his other businesses. (CSU.)

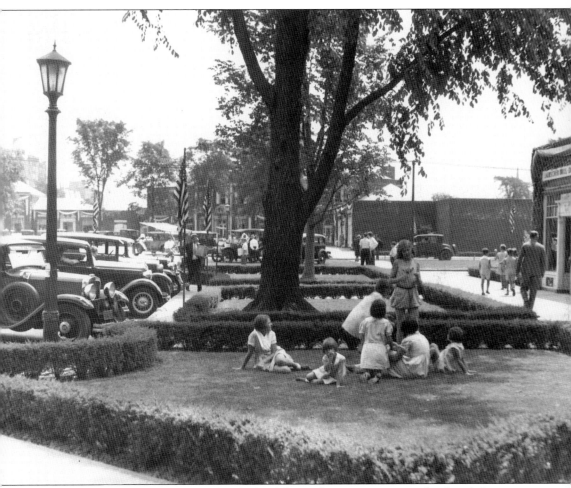

Lounging at Shaker Square. The ideals of the garden city movement also found their way into the design of Shaker Square, which features considerably more green space than modern shopping centers. It was laid out not just for selling merchandise but for providing a place of relaxation and renewal. Here a group of children stretch out over the carefully manicured lawn in 1933. (CSU.)

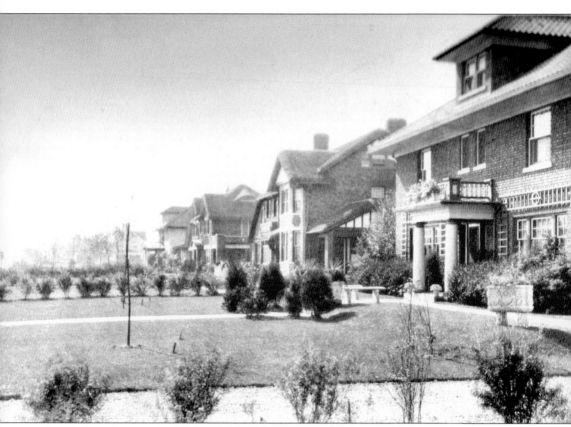

SEDGEWICK ROAD, 1923. Deep front yards, extensive landscaping, traditional styles, detailing, a feeling of comfort and hospitality—these characterized the Shaker Heights home. Each was required to be two stories, placed at a uniform distance from the street, and set apart from others to allow light to enter from all sides. A house should not stand out from its neighbors and call attention to itself; each should fit within the context of its neighborhood. There was diversity in Shaker Heights housing, but this was carefully planned diversity. Uniform lot sizes for each street helped insure a consistent appearance with smaller lots in some sections of the city to provide housing for those of different income levels. These houses on Sedgewick Road have frontages of 100 feet each. Less expensive homes could be found on streets featuring frontages of 75, 60, 50, or 40 feet. Yet throughout Shaker Heights, the architectural and building standards were maintained. A cheaper house did not mean shoddy construction, and architectural standards were the same throughout the community. (SHPL.)

Five

The Shaker
Heights Home

At the center of the Shaker Heights ideal was the home and the effect of a gracious house upon its inhabitants. The Shaker Heights home was to be a place of solace and serenity where one could rest and be renewed. It would be an environment in which children grew and thrived, where adults found a life that was pleasant and dignified—a context that fostered development of character and refinement in all who lived there.

The homes were designed to support this vision. The architecture was conservative, drawing from traditions that had developed comfortable and inviting homes. Interiors were spacious with high ceilings and large windows to let in light. Amenities such as fireplaces and centrally placed staircases conveyed a sense of warmth and charm. There were rooms with sufficient capacity to host large family gatherings but also private spaces to allow for solitude and times of reflection.

Each house was different, but there was a harmonious blending of all structures in the community: houses and public buildings. They all looked like they belonged. While the houses may appear lavish when viewed from another era, they were designed to express dignity and restraint, avoiding both the elaborate ornamentation of the Victorian era and the experimentation of modern architecture.

And these houses were solidly built, underscoring the promise of permanence that came with purchase of a house in Shaker Heights. Unlike the areas of Cleveland that had fallen into decline, Shaker Heights was going to stay the same. The houses were designed to last; the character of the neighborhoods was also protected by deed restrictions that controlled what was going to be built, how it was going to be built, and for what purposes these structures would be used.

A Van Sweringen Company publication expressed the ideal "Home is more than a house, even as character is more than a beautiful face. Yet, even as character may combine with personal grace, so may my house have symmetry, convenience, and charm which shall be so invested with our home-spirit that all may say, *Here is the home of a happy family.*"

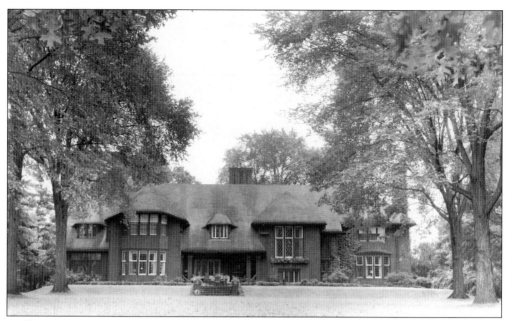

A Crown upon the Highlands. According to a sales brochure of the Van Sweringen Company, "Just to the east of the city and a hundred feet above it, gained through a narrow gateway hewn in the solid rock, lies a vast reservation of homes. Follow the winding highway which rises foot on foot and there, like a crown set upon the highlands, rests Shaker Heights Village." (CSU.)

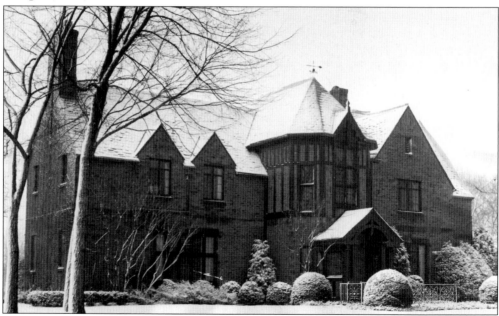

Good Taste in Home Building. Shaker Heights houses were designed to support an ideal life—the utopia of the private home. They offered comfort without extravagance, hospitality tempered by reserve, and spaciousness without overwhelming the inhabitants. Above all, they were to be in good taste, reflecting the preferences of the Van Sweringen brothers. "The most pleasing is never conspicuous—never flashy." (CSU.)

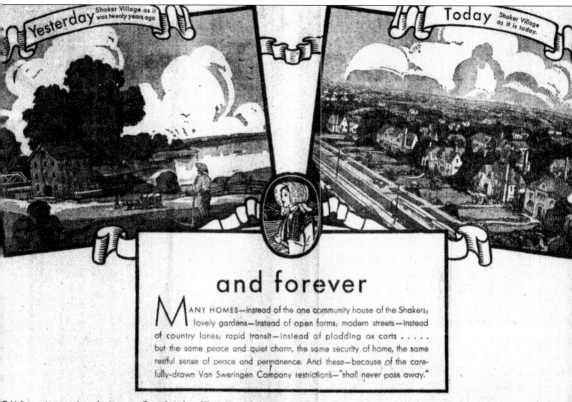

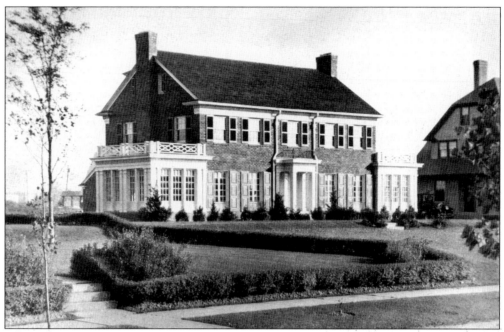

COLONIAL-STYLE HOUSE. The Van Sweringens chose three basic styles for Shaker Heights homes: Colonial, English, and French. Within each of these were variations. Colonial came in Georgian, Federal, and Greek Revival. English came in Tudor, Early English, and Renaissance. French styles included Country Chateau and Classical/Renaissance. Most community buildings were in Colonial style. (SHPL.)

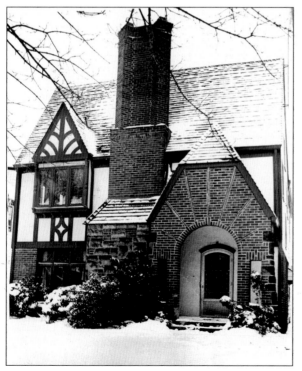

ENGLISH-STYLE HOUSE. Over a dozen architects designed houses in Shaker Heights. They did not produce copies of existing structures but individual creations based on themes found in Colonial, English, or French styles. Shaker Heights houses, then, are unique creations as they also elicit memories of older structures from places far away from Ohio. (CSU.)

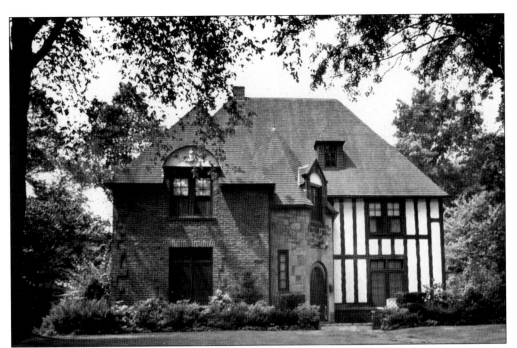

FRENCH-STYLE HOUSE. The architects of Shaker Heights houses paid close attention to the neighborhood context in which their buildings were placed. They sought an overall harmony among the structures. Even though houses lining a street might draw from different traditions, they all appeared to belong in this neighborhood. They coexisted peacefully. (CSU.)

APPROPRIATE COLOR SCHEMES. A booklet called *Shaker Village Standards* guided building construction throughout the city. The standard was "good taste," which combines things of beauty with features designed for comfort and convenience. A Shaker Heights home was to suggest hospitality and friendliness, tempered by dignity and reserve. To help the builder produce the desired effect, color schemes were included for the three basic styles of homes. (SHPL.)

APPROPRIATE COLOR SCHEMES
For French Residences

Walls	Trim* and Sash	Shutters and Doors	Chimneys	Iron Balconies, Etc.	Roof
1. Weathered brown	Brown	Brown	Common brick	Black	Brown
2. White	White	Brown	Common brick, painted white	Black	Brown
3. Weathered gray	Dark weathered gray	Dark weathered gray	Common brick	Black	Weathered gray
4. Stone color	Dark gray	Dark gray	Stone	Emerald green	Dark gray

*Trim includes fly screens.

For French Residences of Shingled Walls

Brickwork	Stonework	Mortar	Sash and Trim*	Stucco	Blinds	Roof
1. Red range common brick	Variegated sandstone	Natural	Weathered gray	Bank-sand	Blue-green	Weathered gray
2. Over-burned archbrick	Variegated sandstone	Bank sand color	Stone color	Buff	Emerald-green	Brown
3. Common brick burned in bee-hive kiln		Natural	Weathered brown	Bank-sand	Olive-green	Weathered brown
4. Shale face brick laid with backs out		Natural	Weathered gray	Natural	Weathered gray	Weathered gray

*Trim includes screens, half timber and siding.

For French Houses of Brick or Combination

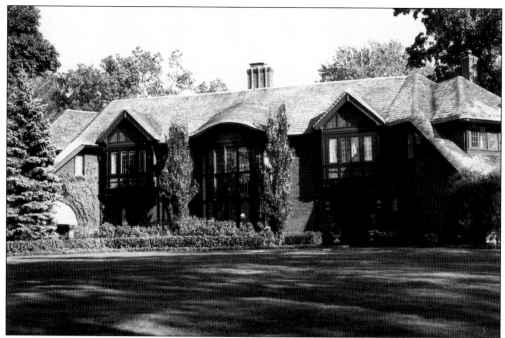

SHAKER BOULEVARD HOME. The newly constructed Shaker Boulevard ran parallel to the rapid transit tracks. This provided an opportunity to showcase luxury homes such as this house built in 1923. Early Shaker Heights residents remembered riding rapid transit trains and seeing these stately mansions under construction. The houses were different than those found in other communities, as was the way of life promised to people who lived in Shaker Heights. (SHPL.)

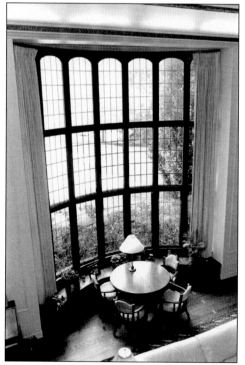

INTERIOR OF SHAKER BOULEVARD HOME. Shaker Heights houses also offered spacious interiors. This home features a two-story living room with leaded-glass windows and a balcony overlooking the living space below. More modest Shaker Heights homes also featured a sense of spaciousness with high ceilings and large windows. (SHPL.)

CENTRAL STAIRCASE. Interior features, such as this prominently located staircase, enhanced the graciousness of these homes. The wood-carved railings on this staircase offer an example of the detailing produced by hundreds of craftsmen employed to work in Shaker Heights homes. Today it is hard to find anyone with the skills to produce comparable work. (SHPL.)

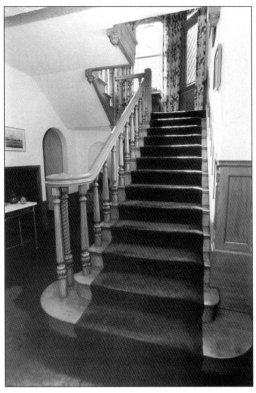

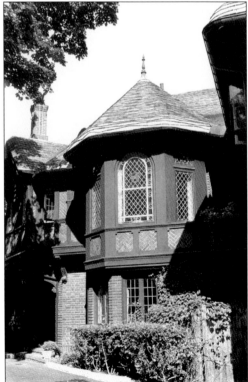

EXTERIOR DETAILING. This rear view of the same Shaker Boulevard home demonstrates that the extensive detailing extended to sections of the structure that would not be in public view. The patterned brickwork on this section was not necessary—stucco would have done just fine. But Shaker Heights homes expressed ambitions that reached beyond what would be "just fine." (SHPL.)

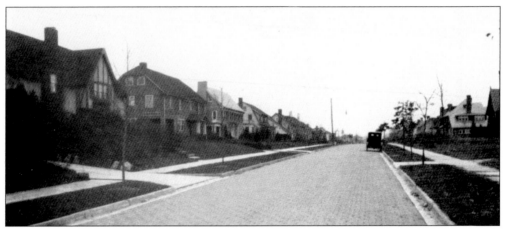

BRIGHTON ROAD, 75-FOOT FRONTAGES. Shaker Heights was divided into distinct neighborhoods with traffic patterns that naturally drew people together. Major roads created borders while less-traveled streets connected those living within a neighborhood. The residential streets sometimes curved, sometimes stretched into unusually long blocks. Both were designed to discourage commercial development, making access inconvenient for any business that might try to establish itself. (SHS.)

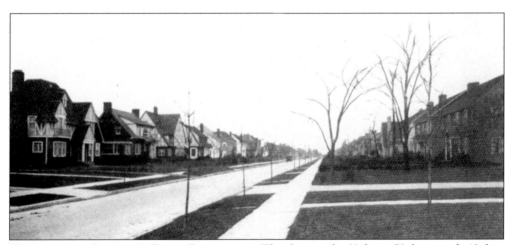

WARRINGTON ROAD, 60-FOOT FRONTAGES. The lots with 60-foot, 50-foot, and 40-foot frontages offered more affordable housing, but no matter what the size of property and no matter where the house was located, the standards applied. Houses had to be architect designed with uniform placement on the property and solid construction throughout. (SHS.)

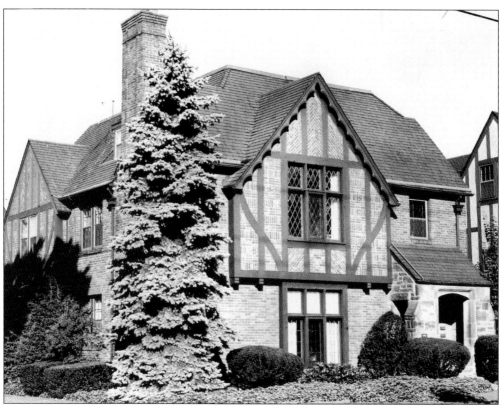

TWO-FAMILY HOME. Houses for two families were allowed in certain sections of the city, but they were not supposed to look like two-family homes. This created opportunities for residence in Shaker Heights for families of lower incomes while retaining the overall appearance of the community. A casual observer would not realize that this home was divided into two distinct sections. (SHPL.)

NOT OUR STYLE. Appropriateness to the neighborhood remains a guideline in Shaker Heights housing. Here a 1952 newspaper article reports that 23 neighbors had gone to court to halt construction on this house which, in their opinion, did not fit. Individual freedoms and community standards sometimes find themselves at odds in Shaker Heights. (CSU.)

SHAKER COURT UNDER CONSTRUCTION, 1941. The original plans for Shaker Heights restricted housing to single-family homes—or houses that appeared to be single-family homes. Later, apartment buildings were constructed within Shaker Heights and in the Shaker Square neighborhood. Today about half of Shaker Heights residents live in single-family homes, the rest in apartments, condominiums, or other multifamily structures. (CSU.)

TENDING THE BEES. Here a group of students receives a lesson in beekeeping with newly constructed houses in the background. Shaker Heights was conceived as especially conducive for raising families with its emphasis on good schools, distinct neighborhoods, and a secure environment. It is perhaps an irony that this family-friendly city was created by the Van Sweringen brothers who never married. (SHCS.)

98

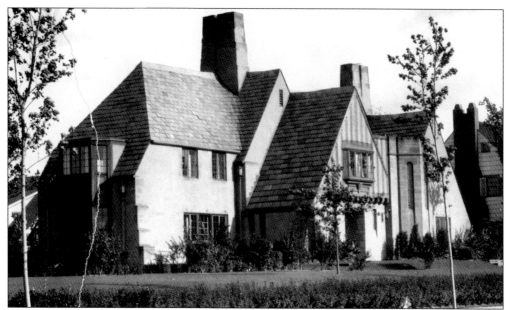

VAN SWERINGEN DEMONSTRATION HOME. The structures created for their city bore marks of the brothers' personalities: conservative, understated, and dignified, as in this Onaway neighborhood home. All Van Sweringen buildings—from Shaker Heights houses to the Terminal Tower—were substantial, built to last. Another irony is that such solid structures were constructed using such tenuous financing. Looking back, it appears that the brothers created something out of nothing. (CSU.)

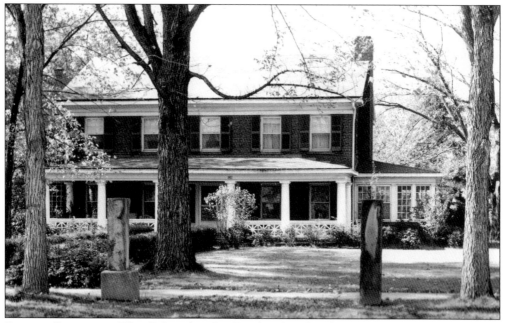

SHAKER GATEPOSTS. This Colonial on Lee Road is placed on land that was once a field used by the North Union Shakers. On the tree lawn in front are two square stone gateposts from the old Shaker community. Those gateposts had marked the entrance to this field; today they stand as a reminder of the earlier residents who once called this area home. (SHS.)

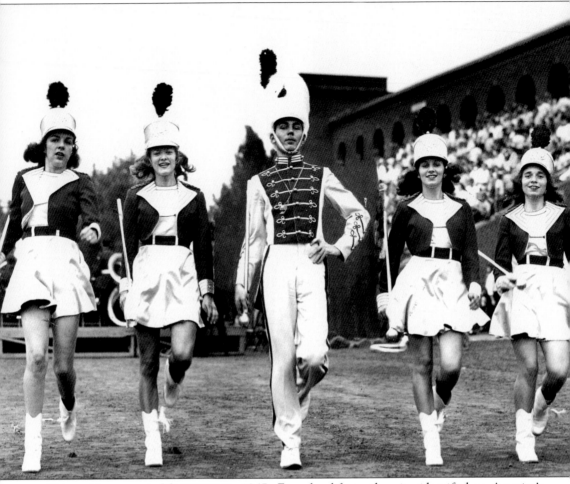

DRUM MAJOR AND MAJORETTES, 1947. Everyday life in the city identified as America's wealthiest looked like everyday life in many American communities. There were high school football games, the band, and a stadium filled with spectators. There were parades and festivals and pageants. Kids played baseball, teens went to dances, dads played golf, and moms went to meetings. Perhaps, though, Shaker was more genteel than the typical American town. Junior high school girls wore blue skirts, saddle shoes, and middy blouses: white on Monday, Wednesday, and Friday, colored on Tuesday and Thursday. Boys wore dark pants and light shirts to school. Female teachers were required to have a pair of white gloves available in case they were invited to a student's house for lunch. Male teachers always wore jackets—if a teacher's jacket clashed with his pants, he was advised to make better choices in the future. A new teacher in the Shaker Heights schools who had grown up in ethnic New Jersey remembered that students addressed him as "Sir." Nobody had ever called him "Sir" before. (SHPL.)

Six

EVERYDAY LIFE
IN AMERICA'S
WEALTHIEST CITY

The United States Census in 1962 identified Shaker Heights as the city with the highest per capita income in the nation. It also cost more to rent here than in any other American community. Since its inception, Shaker Heights had been designed as a community for those who were well-off. Now statistics confirmed that these efforts had been successful.

Shaker Heights was promoted as a community in which people like you would live. Your neighbors would be your friends; you would be surrounded by those with whom you felt comfortable. The country club analogy was often cited. As a country club is a small select association of like-minded people, so too was this a country club city.

The architecture of the homes and community buildings, perhaps unintentionally, conveyed the city's identity. Each house was different, yet they all fit together. Individual variation in architecture was expressed in the context of overall conformity, so too was the population of the community. Shaker Heights was overwhelmingly white, Protestant, and professional. One did not have to be rich to live in Shaker Heights, but a comfortable income was expected. Individual differences among the residents were expressed in the context of a population made up mostly of those who "fit."

A community is defined by who is in it—and who is not. The message of who can be in the club is communicated in many ways, such as in the available religious options. In its first 35 years, six congregations built facilities in Shaker Heights. All were Protestant. It was not until 1945 that a Catholic church was organized in Shaker Heights and not until 1948 that it had its own building. The first Jewish congregation was organized in 1952 and its building dedicated in 1957.

Shaker Heights was never completely exclusive. Catholics and Jews owned homes in Shaker Heights from the beginning and, occasionally, people of color lived in the community. Most residents, however, could relax in the assurance that they lived in a protected environment, as the Van Sweringens had promised so many years before.

But change was in the air.

HORSESHOE LAKE. The lakes created by the Shakers when they dammed Doan Brook continued to offer a serene locale. Here two boys gaze over the placid waters of Horseshoe Lake. The Shaker Lakes played an important role in Shaker Heights, representing the calm and peaceful life to which the community aspired. (SHPL.)

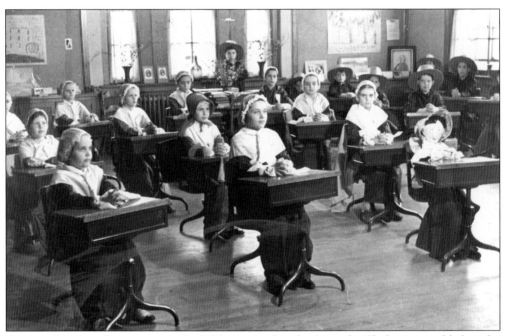

SHAKER STUDIES CURRICULUM. In 1929, a unit of study about the Shakers was added to the third-grade curriculum in the Shaker Heights schools. In this photograph taken at Malvern School, girls and boys—and a doll in the front row—are dressed as Shakers. The girls and boys are separated as the sisters and brothers had been separated among the Shakers. (SHS.)

SHAKER EARLY SETTLERS' DINNER.
Shaker Heights residents kept the
memory of the North Union Shakers
alive in several ways. Stop signs
within the city were decorated with
an idealized drawing of a Shaker
woman, as were city publications.
Here is a participant at a dinner with
a Shaker theme held at Boulevard
School in 1938. (SHPL.)

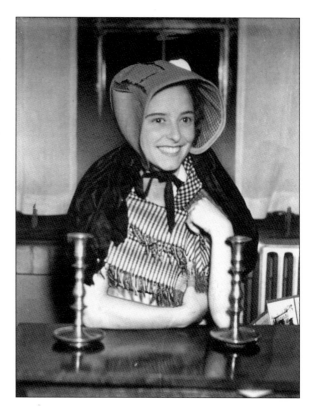

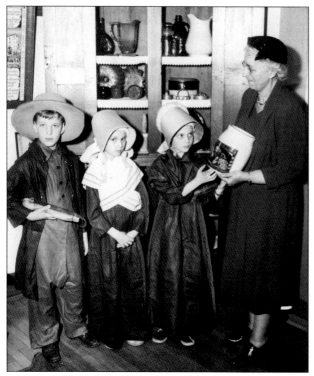

SHAKER HISTORICAL SOCIETY.
In 1947, the Shaker Historical
Society was founded to study
and preserve the history of the
Shakers and of Shaker Heights.
The society conducts educational
programs, publishes materials
related to its mission, and
maintains a museum on South
Park Boulevard. In this 1956
photograph Elizabeth Nord, first
curator of the Shaker Historical
Museum, shows a Shaker apple
butter crock to children at
Moreland School. (SHPL.)

WOMEN AT SHAKER HEIGHTS COUNTRY CLUB. Husbands in Shaker Heights had jobs and went to work each morning. Wives did not work outside the home. Sometimes in exceptional circumstances—such as the death of a spouse—a wife took a job to support her family. But this was unusual, a departure from the norms that governed the community. (CSU.)

FATHER AND DAUGHTER FOURSOME. Shaker Heights residents had their choice of two country clubs located within the city and a municipal golf club adjoining it. There were also a riding academy, a tennis club, and a canoe club. This is a 1933 photograph taken at the Shaker Heights Country Club. (CSU.)

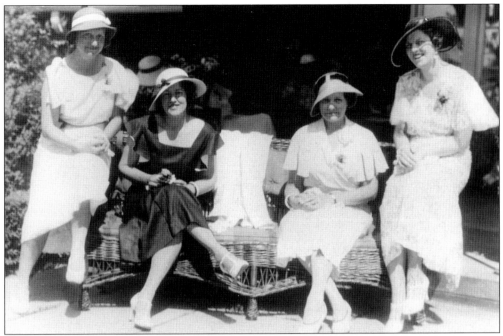

THE FLOWERPOT GARDEN CLUB. According to a newspaper announcement, "The July 10 meeting of the Flowerpot Garden Club will be Guest Day and will be held at the Canterbury Golf Club, where members will stage their annual flower show. Mrs. A. S. Orme will be hostess, with Mrs. R. F. Cate, Mrs. F. M. Elton, Mrs. H. W. Salter and Miss Florence Warden assisting." (SHPL.)

CYCLE PAGEANT, 1936. Shaker Square became a place of community gathering that hosted events and activities including the annual "Shaker Festival" that featured band music, parades, and the crowning of a May Queen. Here two boys dressed in their baseball uniforms show off tricycles they have decorated for the cycle pageant. (SHPL.)

SCANNING THE SKIES. The Van Sweringens hoped that a merger between Case Institute of Technology and Western Reserve University would establish a "University of Cleveland" in Shaker Heights. It did not happen, and land reserved for that purpose became the Hathaway Brown School campus. They did persuade St. Ignatius College to move to the area, where it was renamed John Carroll University. This 1935 photograph shows Hathaway Brown students. (CSU.)

HARMONICA BAND. The Moreland School Harmonica Band, in formation, creates the M that represents its school. This photograph, taken during the 1930s, gives a good view of how a harmonica band in uniform looks. It is, however, difficult to imagine how it would sound. (SHCS.)

BUILDING AN AIRPLANE. This photograph shows a Shaker Heights Junior High School student at work on a classroom project, building a working model airplane. It is an example of the style of instruction in the schools that encouraged participation and direct experience rather than just rote learning. (SHCS.)

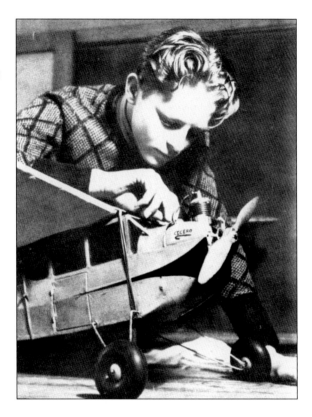

MARCHING BAND. Shaker Heights schools have always offered opportunities to participate in the arts—theater, creating artwork, and music—and some of its graduates have gone on to full-time careers in their chosen realms of artistic endeavor. Here the tuba player takes center stage as the high school band performs its halftime show. (SHCS.)

STARTING A BASEBALL GAME. This photograph could have been taken anywhere in America as boys choose up to start a baseball game. In fact, it is in Shaker Heights at Lomond School in 1947. (SHPL.)

ALUMNI SQUARE DANCE. Graduates of University School in Shaker Heights return to their alma matter in 1948 for the alumni square dance. (CSU.)

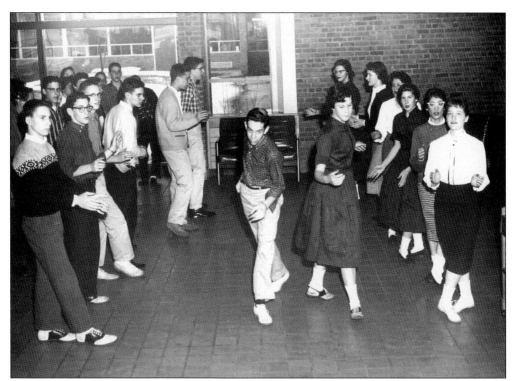

Junior High School Dance. This dance was held at Shaker Heights Junior High School in 1959. The center dancers are identified as Jamie Hukill and Pat Lovshan. Most of the young people in this photograph are 14 years old. (CSU.)

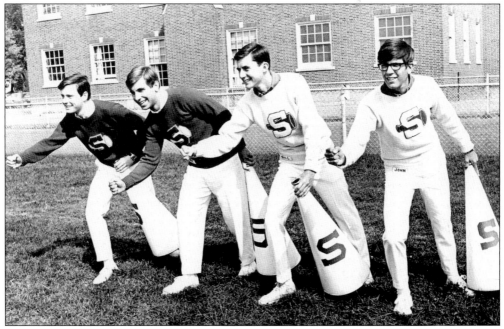

Cheerleaders. Members of the Shaker Heights High School cheerleading squad take to the field in 1967. (CSU.)

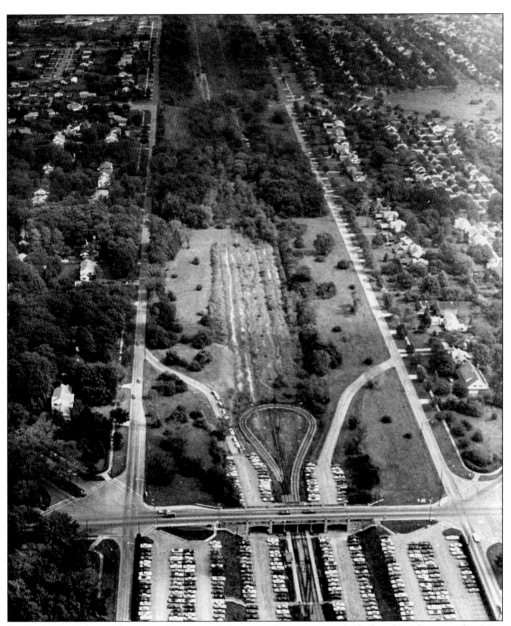

PROJECTED RAPID TRANSIT ROUTE. A key to the success of Shaker Heights, as the Van Sweringens conceived it, was an efficient route to downtown Cleveland where most potential buyers worked. At the time, streetcars were too slow, and even those who owned private automobiles found the journey downtown daunting. The new rapid transit line completed the trip in 21 minutes, which made it possible for the Van Sweringen Company to claim that Shaker Heights combined the best of country and city living. The Van Sweringen brothers had plans to develop land farther east. They conceived of Shaker Estates, a region of larger homes on more spacious lots all, of course, served by rapid transit service, which would extend to Gates Mills and Chagrin Falls. The bankruptcy of the Van Sweringen Company ended those plans. This photograph shows that considerable space had been reserved for extending rapid transit tracks beyond today's Green Road terminus. (CSU.)

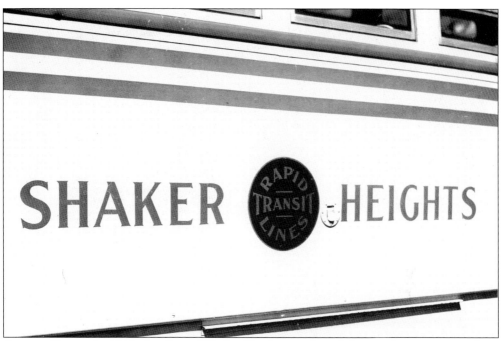

SHAKER RAPID. In 1944, the City of Shaker Heights purchased the rapid transit system from the bankrupt Van Sweringen Company. For over 30 years, it was a municipally operated line financed from fares paid by riders. Rapid transit had provided the link to Cleveland's downtown that made the development of Shaker Heights feasible. Now the city that the "Rapid" had built stepped in to keep its train on the tracks. (CSU.)

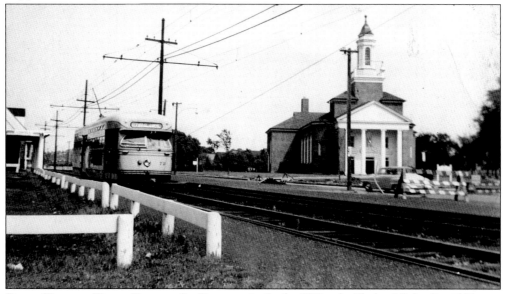

RAPID TRANSIT TRAIN PASSING ST. DOMINIC'S. By the 1970s, the Shaker Hights Rapid Transit was losing money and needed upgrading; the city gave the line to the newly organized Regional Transit Authority. The RTA paid nothing for the Shaker Heights line but agreed to perform necessary repairs and upgrades in order that it continue to provide service. Here a train passes St. Dominic's Catholic Church. (CSU.)

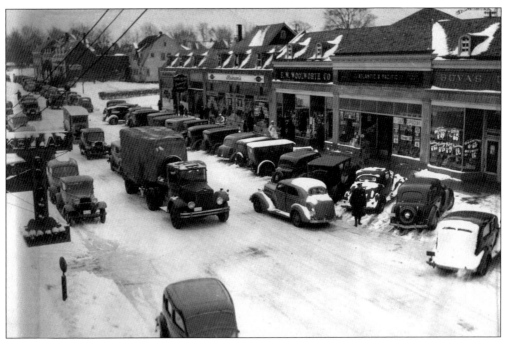

KINSMAN ROAD SHOPPING DISTRICT. Stores were permitted along Kinsman Road near Lee Road. In this 1936 photograph are several familiar stores including Woolworth's, A&P, and Heinen's grocery store, which had its beginnings as a meat market at Kinsman and Lee. Later it expanded into a regional chain of supermarkets. (CSU.)

STOUFFER'S AT SHAKER SQUARE. Abraham and Mahala Stouffer's dairy stand in downtown Cleveland was the start of the Stouffer Corporation. After World War II, they opened this Shaker Square restaurant, known for its service and elegance. Here the restaurant began offering frozen portions of its meals for patrons to take out; this later developed into the Stouffer's brand of frozen foods sold in grocery stores. (CSU.)

HOUGH BAKERY AT SHAKER SQUARE. Another classic Cleveland business with a store at Shaker Square was Hough Bakery. The Hough Home Bakery first opened in 1903 on Hough Road in Cleveland, and it became an institution throughout the community. The outlet shown in this 1949 photograph was located in Marshall's Drug Store where a patron places his order in front of a showcase filled with baked goods. (CSU.)

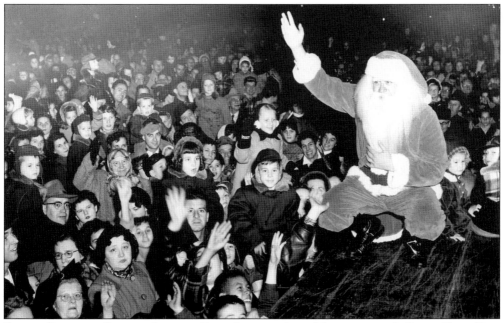

SANTA COMES TO SHAKER SQUARE. Even the nation's wealthiest city needs Santa Claus. Here he makes an evening appearance in 1949 at Shaker Square, surrounded by his fans. Today the tradition of lighting Shaker Square for the holidays continues. (CSU.)

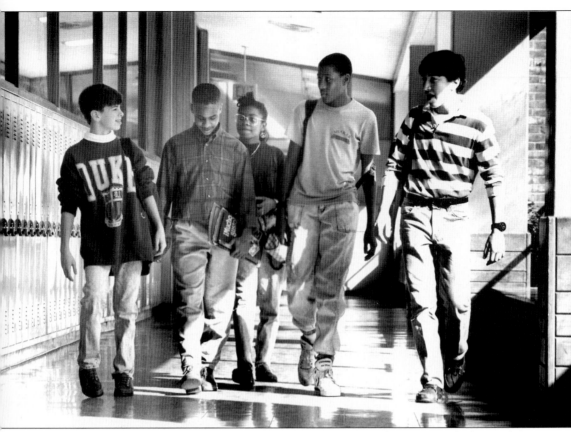

MIDDLE SCHOOL STUDENTS. The original vision for Shaker Heights conceived of a population that was mostly wealthy, white, and Protestant. Few Roman Catholic and Jews made their homes in the city, and African American residents were mostly domestic servants. But that changed as the economic status of minorities improved, as restrictive covenants were outlawed, and as a more diverse population moved into the city. From its beginnings, Shaker Heights had been a planned community—as was the North Union Shaker settlement before it. When the population began to change, Shaker Heights residents drew upon that tradition to manage the transition into a more open, more inclusive community while keeping attributes that residents valued. Today the community embraces a rich diversity while retaining the look of the "Peaceful Shaker Village." (SHPL.)

Seven

REINVENTING
SHAKER HEIGHTS

Despite pledges that Shaker Heights would remain the same forever, change did come. The housing stock, solid though it was, began to age. Proximity to the city raised fears of crime. And a new generation of people who could afford to live in Shaker Heights were African Americans.

In 1925, a black physician and his family moved to Shaker Heights. Shots were fired at the house and the garage torched. Police assigned for protection harassed the family, searching them as they entered and left their home, and the family ultimately left. Residents formed the Shaker Heights Protective Association, which drew upon the country club analogy to claim that neighbors have a right to determine who can join the neighborhood. While race was not mentioned, many have argued that the purpose was to keep out those who did not "fit," especially African Americans.

In 1954, a bomb exploded at a home under construction for a prominent black attorney. Neighbors rallied again, but this time their purpose was different. Instead of devising plans to keep people out, this group—the Ludlow Community Association—started a process of working together to establish a stable diverse community.

Another challenge to the community appeared in 1964 when the Cuyahoga County Highway Department announced that two freeways would cut through Shaker Heights. Fearing the effects, citizens banded together to oppose the freeways and, surprisingly, they won. The Nature Center at Shaker Lakes was established, insuring that no super highways would ever be built in that area.

In 1970, the Shaker Heights city schools addressed the increasing diversity of its student body by creating the Shaker Schools Plan, a voluntary busing program that promoted integration. In 1987, the school board followed up by reorganizing elementary schools for racial balance. Plans developed in Shaker Heights schools have been followed throughout the nation as a model for providing excellent education while serving a diverse student body.

The result is a reinvented Shaker Heights. It is still a planned community, but the goals have changed, and today the city has been able to realize an elusive dream: a stable diverse community.

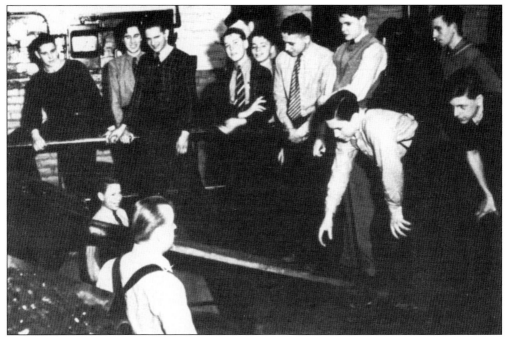

WHITE SHAKER HEIGHTS. A 1938 book produced by the board of education displays 126 pages of photographs depicting life in the Shaker Heights schools. The students are shown benefiting from an innovative approach to education in which substantial resources were available to them. No people of color appear on those pages. (SHCS.)

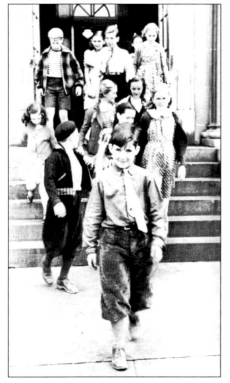

MALVERN SCHOOL, 1930s. Shaker Heights sought to establish continuity with the North Union Shakers, but in this regard there was a difference: the Shakers featured more diversity than Shaker Heights. Among North Union residents were Native Americans, an ex-slave, a German Jew, and a Swiss ex-priest. The Shakers welcomed all seekers of truth; Shaker Heights would have to work on that one. (SHCS.)

PROGRAM PROMOTING INTEGRATION.
Restrictions on Shaker Heights
deeds had put controls on who could
buy property in the city, but such
covenants throughout the nation were
ended by decision of the United States
Supreme Court in 1948. Already,
though, Shaker Heights was changing.
African American families had
purchased houses in western sections
of Shaker Heights, and new apartment
buildings increased the economic and
racial diversity of residents. White
flight threatened. (SHPL.)

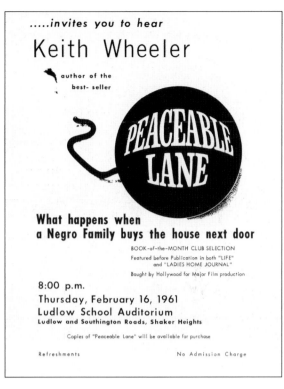

.....*invites you to hear*

Keith Wheeler

author of the
best- seller

PEACEABLE LANE

**What happens when
a Negro Family buys the house next door**

BOOK-of-the-MONTH CLUB SELECTION

Featured before Publication in both "LIFE"
and "LADIES HOME JOURNAL"

Bought by Hollywood for Major Film production

**8:00 p.m.
Thursday, February 16, 1961
Ludlow School Auditorium**
Ludlow and Southington Roads, Shaker Heights

Copies of "Peaceable Lane" will be available for purchase

Refreshments No Admission Charge

KINSMAN BECOMES CHAGRIN.
This hand-lettered sign announces
a name change from Kinsman Road
to Chagrin Boulevard. Kinsman was
an early route in the area running
from Cleveland to Kinsman, Ohio.
A series of violent incidents on
Kinsman in Cleveland inspired
Shaker Heights, in 1959, to change
the name of its section to Chagrin
Boulevard as Shaker Heights sought
to distance itself from Cleveland's
problems. (SHPL.)

The time to protect the property on your street is today — tomorrow may be too late.

Sign the enclosed card *Today.*

SHAKER HEIGHTS PROTECTIVE ASSOCIATION. In 1925, 400 prominent residents formed the Shaker Heights Protective Association after a black family attempted to make a home in Shaker Heights. This association warned that "undesirable" neighbors could move into the city if "restrictions" were not put into place. While race was not explicitly mentioned, such restrictive covenants were used nationwide to keep minorities out of communities. (SHPL.)

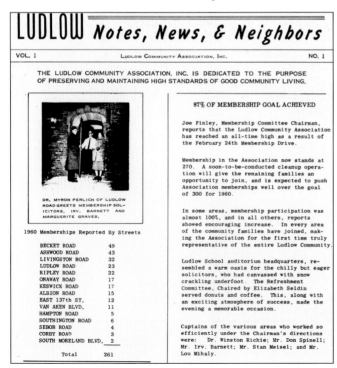

LUDLOW *Notes, News, & Neighbors*

VOL. 1 LUDLOW COMMUNITY ASSOCIATION, INC. NO. 1

THE LUDLOW COMMUNITY ASSOCIATION, INC. IS DEDICATED TO THE PURPOSE OF PRESERVING AND MAINTAINING HIGH STANDARDS OF GOOD COMMUNITY LIVING.

DR. MYRON PERLICH OF LUDLOW ROAD GREETS MEMBERSHIP SOLICITORS, IRV. BARNETT AND MARGUERITE GRAVES.

87% OF MEMBERSHIP GOAL ACHIEVED

Joe Finley, Membership Committee Chairman, reports that the Ludlow Community Association has reached an all-time high as a result of the February 24th Membership Drive.

Membership in the Association now stands at 270. A soon-to-be-conducted cleanup operation will give the remaining families an opportunity to join, and is expected to push Association memberships well over the goal of 300 for 1960.

In some areas, membership participation was almost 100%, and in all others, reports showed encouraging increase. In every area of the community families have joined, making the Association for the first time truly representative of the entire Ludlow Community.

Ludlow School auditorium headquarters, resembled a warm oasis for the chilly but eager solicitors, who had canvassed with snow crackling underfoot. The Refreshment Committee, Chaired by Elizabeth Seldin served donuts and coffee. This, along with an exciting atmosphere of success, made the evening a memorable occasion.

Captains of the various areas who worked so efficiently under the Chairman's directions were: Dr. Winston Richie; Mr. Don Spinell; Mr. Irv. Barnett; Mr. Stan Meisel; and Mr. Lou Mihaly.

1960 Memberships Reported By Streets

Street	
BECKET ROAD	49
ASHWOOD ROAD	43
LIVINGSTON ROAD	32
LUDLOW ROAD	23
RIPLEY ROAD	22
ONAWAY ROAD	17
KESWICK ROAD	17
ALBION ROAD	15
EAST 137TH ST.	12
VAN AKEN BLVD.	11
HAMPTON ROAD	5
SOUTHINGTON ROAD	6
SEBOR ROAD	4
CORBY ROAD	3
SOUTH MORELAND BLVD.	2
Total	261

LUDLOW COMMUNITY ASSOCIATION. The response to a bombing directed against an African American family in the 1950s was different. Neighbors came together first to help the family clean up the damage, and then blacks and whites began a dialogue. These conversations coalesced into a desire to maintain the Ludlow neighborhood as an environment where white and black families could live together in a shared community. (SHPL.)

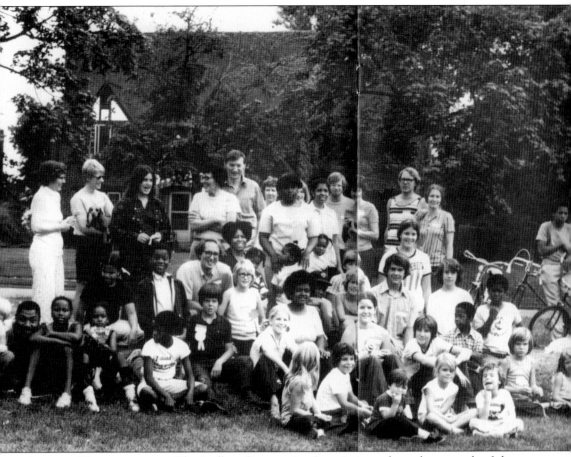

LUDLOW NEIGHBORHOOD. The Ludlow Community Association—formed as a result of these conversations—embarked upon an innovative plan to maintain the quality and diversity of the Ludlow neighborhood. One program encouraged white buyers to move into Ludlow and offered loans for that purpose while also encouraging black families to move into areas of Shaker Heights in which mostly white families lived. (SHPL.)

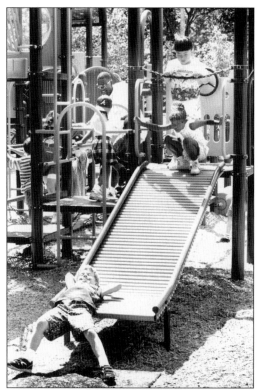

NEIGHBORHOOD PLAYGROUND. Building upon a long-standing Shaker Heights value, residents realized that an integrated city does not just happen; it takes planning. In 1967, the Shaker Housing Office was formed and began a loan program—as well as a national advertising campaign—aimed at promoting diversity throughout the city. (SHPL.)

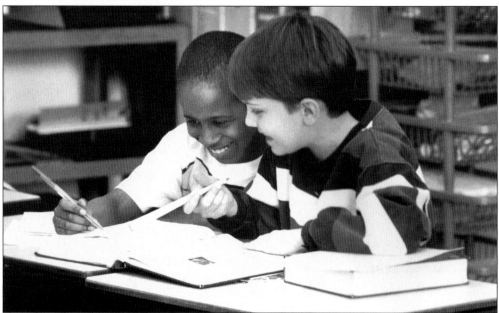

STUDENTS READING. The schools faced similar challenges. As minority families moved into areas served by Shaker Heights city schools, elementary schools were becoming segregated. In 1970, the board of education adopted the Shaker Schools Plan, a voluntary busing program that promoted integration. In 1987, the board of education reorganized the elementary schools for racial balance. Both plans have been models for school districts nationwide. (SHPL.)

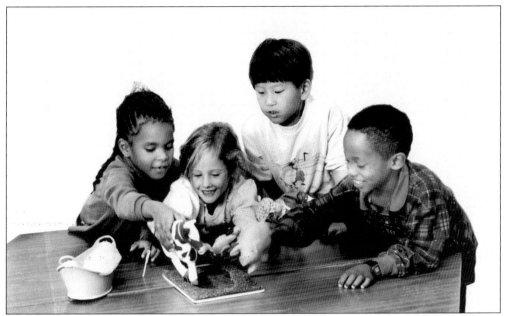

PLAYING TOGETHER. The result has been another benefit for students in Shaker Heights schools. Not only do they receive a high-quality education based on innovative approaches to learning, they also share this experience in a diverse student body. Shaker Heights schools offer an environment in which young people become familiar with life in a multiracial and multicultural community. (SHPL.)

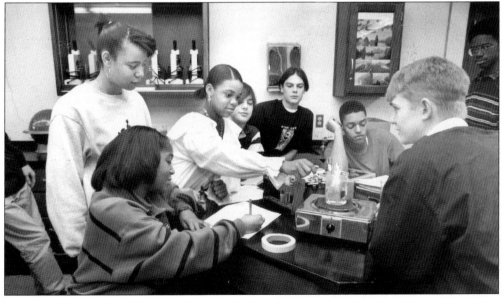

WORKING TOGETHER. Friendships among students in elementary school that crossed the color lines often did not survive into middle school and high school. In response, students formed an organization to help maintain healthy relationships within a diverse student body. Called the Student Group on Race Relations, about 250 volunteers present programs to fourth and sixth graders each year that help create and sustain healthy relationships among people of different races. (SHPL.)

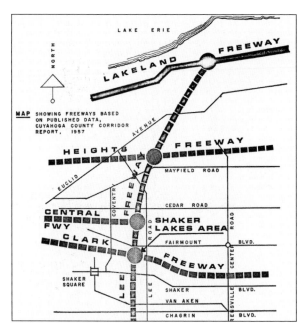

CLARK AND LEE FREEWAY ROUTES. Another potentially convulsive change for Shaker Heights was initiated by the Cuyahoga County Highway Department in 1964 when it announced plans to build two eight-lane freeways through the city. An estimated 100,000 vehicles would use these roads daily. At the time, highways were an easy sell with most communities eager to get them. Not Shaker Heights. (NCSL.)

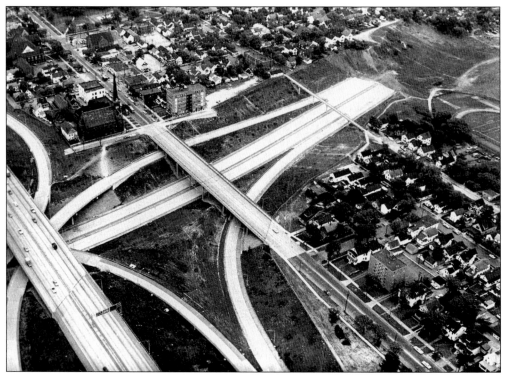

START OF CONSTRUCTION, CLARK FREEWAY. The freeways seemed inevitable. Money had been allocated, construction had begun, and, besides, freeways represented progress. The highway department sought to mollify residents with assertions that freeways increased the value of adjacent properties, had no appreciable effect upon noise or pollution levels, and made life easier for everybody. The start of the Clark Freeway at Interstate 71 is pictured here. (CSU.)

CITIZEN ACTION AGAINST THE FREEWAYS. Community groups united to fight the freeways, including the Shaker Historical Society, the Audubon Society, and a coalition of 33 garden clubs. They mounted a campaign of intense pressure on elected officials to stop the freeways. During a snowstorm in January 1970, opponents came out in force to state their case. The following month, the governor announced that the freeways would not be built. (SHS.)

```
                LITERATURE PROTESTING CLARK FREEWAY
Prepared and Distributed by Freeway Committee - Shaker Historical Society

READING MATTER - (148,000 pages, including Reader's Digest Reprint)

13,000  Sheet #1 - Says Clark Freeway Perils Doan Valley
                   State Determined on Clark Freeway - 3 articles

13,000  Sheet #2 - How the Clark Freeway Will Affect You
                   The Clark Freeway Will Destroy Historical Monuments

13,000  Sheet #3 - All in the Name Of Progress - Sun Press Cartoon
                   Conservation - letter of Cleveland Audubon Society

14,000  Sheet #4 - Effective Letter Writing - Human Events
                   To Your Congressman - how to write letters

 6,000  Sheet #5 - SHS Letterhead - Help Us Stop the Clark Freeway
                   New York Times - Ohio Community Fights Freeway

10,000  Readers Digest - Goodby to our Public Parks - 3 pages reading

   DISTRIBUTION of the above material was:

 7,000 sets to Meetings: Pta, School, Conservation, Libraries, Garden
                   Clubs, Service Groups

 6,000 sets Direct Mail (including Citizens Committee Freeway Facts)
            to All-Ohio mailing lists of: Museum Natural History; Garden
            Centers mailing to all Garden clubs, affiliated and not affil-
            iated; Cleveland Audubon Society;  All Shaker residents
            whose home would be taken by Clark Freeway, Sun Press list;
            All Boy Scout leaders in Cleveland Heights, Shaker Heights and
            Woodland Hills Districts;  All Girl Scout leaders in Shaker
            and Cleveland Heights

OTHER DISPLAY MATERIAL - circulated or donated for permanent exhibit

 107 CHARTS - Freeway Interchanges, and sections of Aerial Map of Freeway
            Total of 9 different views, 18x24" mounted with captions, easel back
            Distributed to: Shaker Schools, Shaker Museum, both Shaker Libraries
            University School, Hathaway Brown,  Beaumont School, St Lukes
            Hospital,  East End Neighborhood House; 3 sets to Madelaine Bovito
            who covered churches and libraries in Cleveland, 1 set to Citizens
            Freeway Committee (which they paid for); Case Tech;  Reserve Univ.

  24 BOOKS   11 copies - Blake - God's Own Junkyard
             8  "      - Mumford - Highway and the City
             5  "      - Udall - The Quiet Crisis

 1,000 Maps - 8½x11 size - Porter's Proposed Freeways for Cuyahoga County
     6  "    - 27"x33"   -    "        "         "       "      "
```

NATURE CENTER TRUMPS A FREEWAY. Ironically, the early Shakers played a role in deciding this controversy. Over a century earlier, they had created two lakes by damming Doan Brook. Developers retained the lakes and donated them to the Cleveland Park Commission. In 1968, a new federal law prohibited building freeways in public parks. The Nature Center at Shaker Lakes was established as a resource for conservation and education. (NCSL.)

MAKING POTTERY. Beginning with the North Union settlement, residents of this community have sought to build an ideal society. The Shakers created a way of living they believed God had established for those of the most developed spirituality. The Van Sweringens' Shaker Heights continued utopian themes offering residents a life of harmony and serenity, not in a cooperative community but in a city of exclusive homes and gardens. (SHPL.)

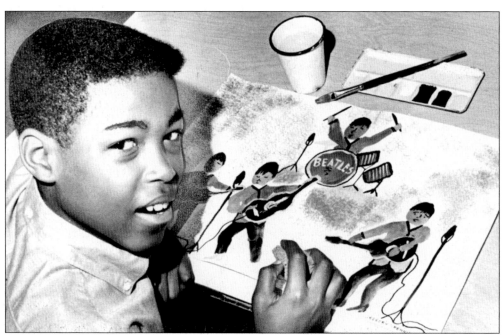

GREGORY PENNINGTON PAINTS THE BEATLES. Today's Shaker Heights has again reinterpreted the utopian model. Now the ideal community includes people of different races and cultures living with mutual respect and affirmation. In such a community, each has opportunities to develop his or her own talents, such as in this photograph of a participant in an arts enrichment program sponsored by the Shaker Heights city schools. (SHPL.)

SHAKER HEIGHTS CHILDREN. The vision of what an ideal community should be has changed from generation to generation, but the methods of achieving it are similar. Central to the Shaker and the Shaker Heights method is intense planning aimed at creating an environment that will bring out the best in its residents. As the Van Sweringen Company put it, "Most communities just happen; the best are planned." (SHPL.)

MEMBERS OF THE BAND. Another quality that extends throughout the generations is a sense of distinctiveness, that something unique and important happens here. "We had been part of a unique experiment in integration," said one person who grew up in the Ludlow neighborhood. The tradition of "unique experiments" is long-standing in this community. (SHPL.)

PLEDGE OF ALLEGIANCE. Perhaps what Shaker Heights offers—in addition to its housing and green space and schools—is something to believe in. It is the dream of a vital community that extends back to the Shakers, a dream that is never fully realized but that does occur in moments of everyday life when human connections are made. (SHPL.)

SHAKER GATE. This gate with stone posts from the North Union settlement stands in a park at the northeast corner of Lee Road and Shaker Boulevard. The Shaker meetinghouse once occupied this site, then the Van Sweringen Company's offices, which they shared with the village offices and schools. Today this Shaker gate stands as a reminder of the generations who have contributed to the community of Shaker Heights.

BIBLIOGRAPHY

Dawson, Virginia P. *Hands on the Past: Celebrating the First 50 Years of the Shaker Historical Society*. Shaker Heights, OH: The Shaker Historical Society, 1997.

Forgac, Patricia J. "The Physical Development of Shaker Heights." Master's thesis, Kent State University, 1981.

Haberman, Ian S. *The Van Sweringens of Cleveland: The Biography of an Empire*. Cleveland: Western Reserve Historical Society, 1979.

Harwood, Herbert H. Jr. *Invisible Giants: The Empires of Cleveland's Van Sweringen Brothers*. Bloomington: Indiana University Press, 2003.

The Heritage of the Shakers. Cleveland: The Van Sweringen Company, 1923.

Klyver, Richard D. *Brother James: The Life and Times of Shaker Elder, James Prescott*. Shaker Heights, OH: The Shaker Historical Society, 1992.

Molyneaux, David G., and Sue Sackman, ed. *75 Years: An Informal History of Shaker Heights*. Shaker Heights, OH: Shakers Heights Public Library, 1987.

Peaceful Shaker Village. Cleveland: The Van Sweringen Company, 1927.

Piercy, Caroline B. *The Valley of God's Pleasure*. New York: Stratford House, 1951.

Richter, Cynthia Mills. *Integrating the Suburban Dream: Shaker Heights, Ohio*. Ph.D. diss., University of Minnesota, 1999.

Shaker Heights Ideal Home Sites. Cleveland: Ringle, O. C. and Company, 1904.

Shaker Heights Then and Now. Shaker Heights: Shaker Heights Board of Education, 1938.

Shaker Village Standards. Cleveland: The Van Sweringen Company, 1928.

Toman, James. *The Shaker Heights Rapid Transit*. Glendale, CA: Interurban Press, 1990.

ACROSS AMERICA, PEOPLE ARE DISCOVERING SOMETHING WONDERFUL. *THEIR HERITAGE.*

Arcadia Publishing is the leading local history publisher in the United States. With more than 3,000 titles in print and hundreds of new titles released every year, Arcadia has extensive specialized experience chronicling the history of communities and celebrating America's hidden stories, bringing to life the people, places, and events from the past. To discover the history of other communities across the nation, please visit:

www.arcadiapublishing.com

Customized search tools allow you to find regional history books about the town where you grew up, the cities where your friends and family live, the town where your parents met, or even that retirement spot you've been dreaming about.